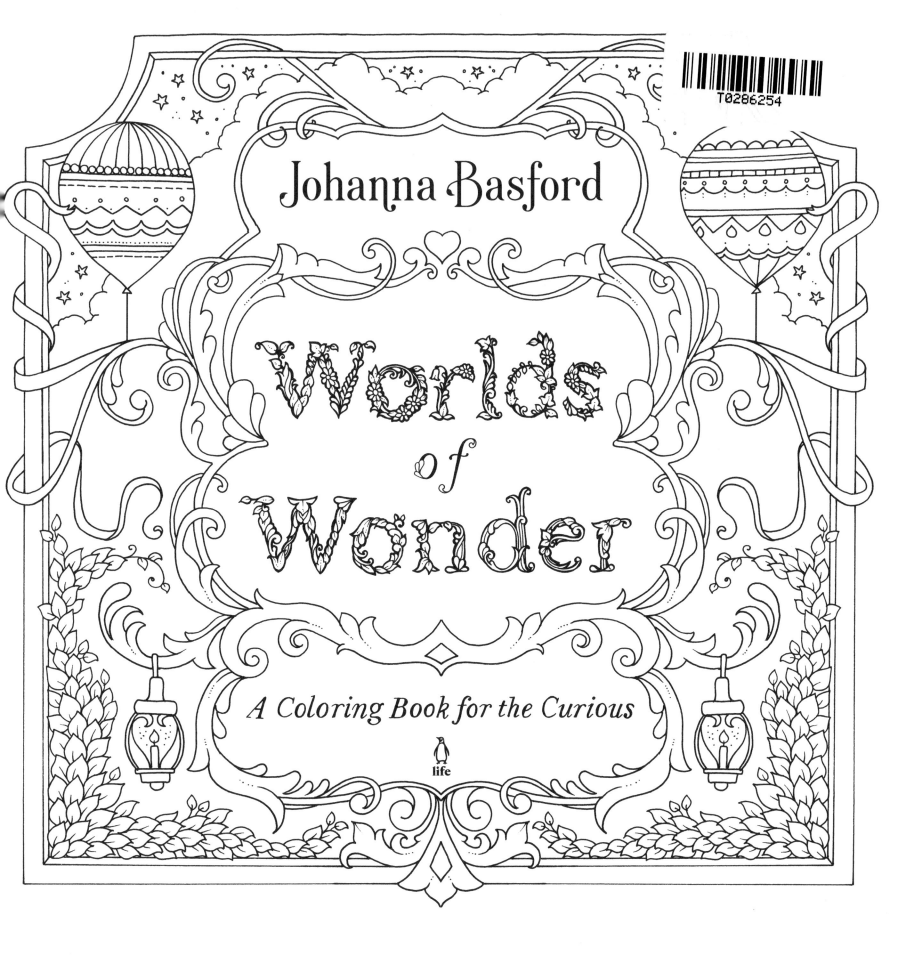

Johanna Basford

Worlds of Wonder

A Coloring Book for the Curious

life

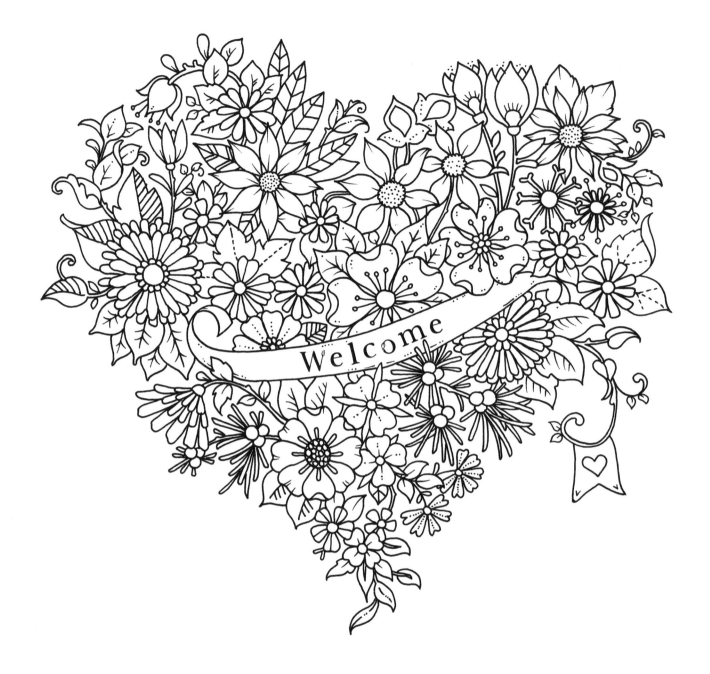

PENGUIN BOOKS

An imprint of Penguin Random House LLC

penguinrandomhouse.com

Copyright © 2021 by Johanna Basford Ltd.

Penguin supports copyright. Copyright fuels creativity, encourages diverse voices, promotes free speech,
and creates a vibrant culture. Thank you for buying an authorized edition of this book and for complying with copyright laws
by not reproducing, scanning, or distributing any part of it in any form without permission.
You are supporting writers and allowing Penguin to continue to publish books for every reader.

A Penguin Life Book

ISBN 9780143136064

Printed in China

9 10 8

Interior designed by Johanna Basford
and Sabrina Bowers

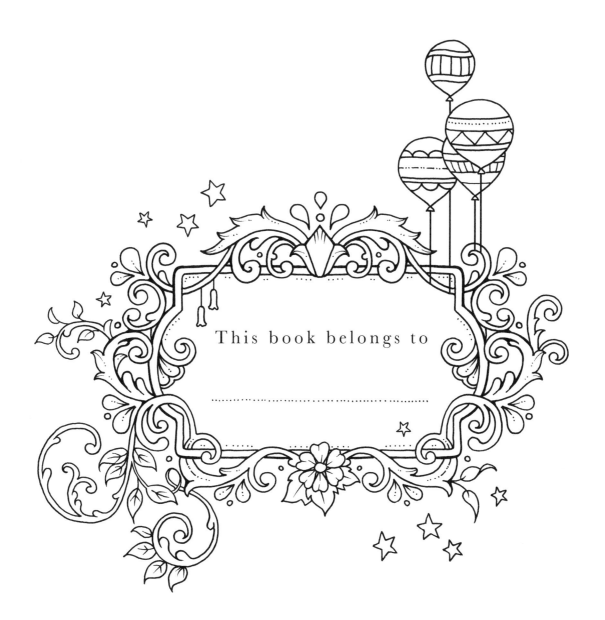

This book belongs to

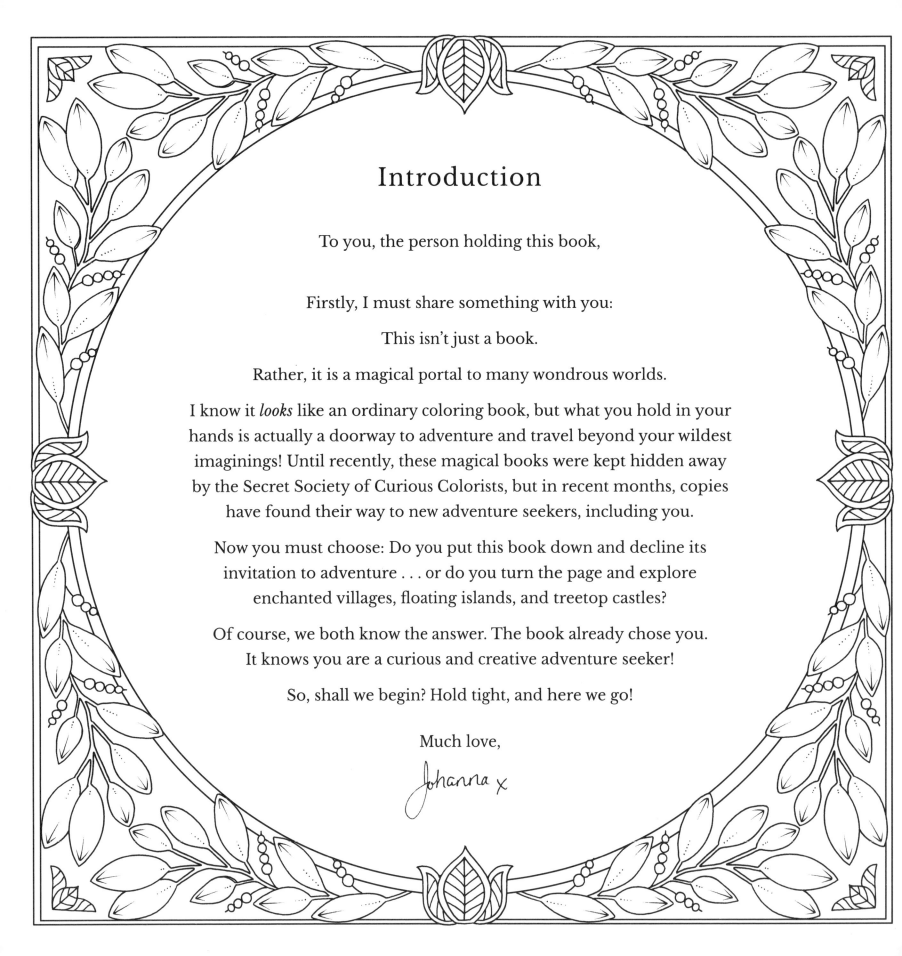

Introduction

To you, the person holding this book,

Firstly, I must share something with you:

This isn't just a book.

Rather, it is a magical portal to many wondrous worlds.

I know it *looks* like an ordinary coloring book, but what you hold in your hands is actually a doorway to adventure and travel beyond your wildest imaginings! Until recently, these magical books were kept hidden away by the Secret Society of Curious Colorists, but in recent months, copies have found their way to new adventure seekers, including you.

Now you must choose: Do you put this book down and decline its invitation to adventure . . . or do you turn the page and explore enchanted villages, floating islands, and treetop castles?

Of course, we both know the answer. The book already chose you. It knows you are a curious and creative adventure seeker!

So, shall we begin? Hold tight, and here we go!

Much love,

Johanna x

A Guide to Exploring Worlds of Wonder

Take coloring pencils on your adventure;
they can be blended and layered to create
many wondrous effects.

If you are tempted by ink, be cautious, bold explorer!
Use the color palette test pages at the back of the book to check if
your ink will bleed through the paper.

Slip a sheet or two of blank paper beneath the page you are
working on to prevent indentation or transfer of ink
to the pages below.

Going outside the lines, adding your own embellishments,
and wandering off the page are all heartily encouraged.

Don't remain in a world if your curiosity is calling you
elsewhere. Turn the page and begin a new adventure—
you can return to worlds anytime you wish.

Share your worlds with like-minded adventurers!
Show friends, upload to my coloring gallery, or share on social
media with #WorldsOfWonder.

The adventure continues. . . .
To unlock hidden pages and join the
Secret Society of Curious Colorists, visit
johannabasford.com/worldsofwonder.

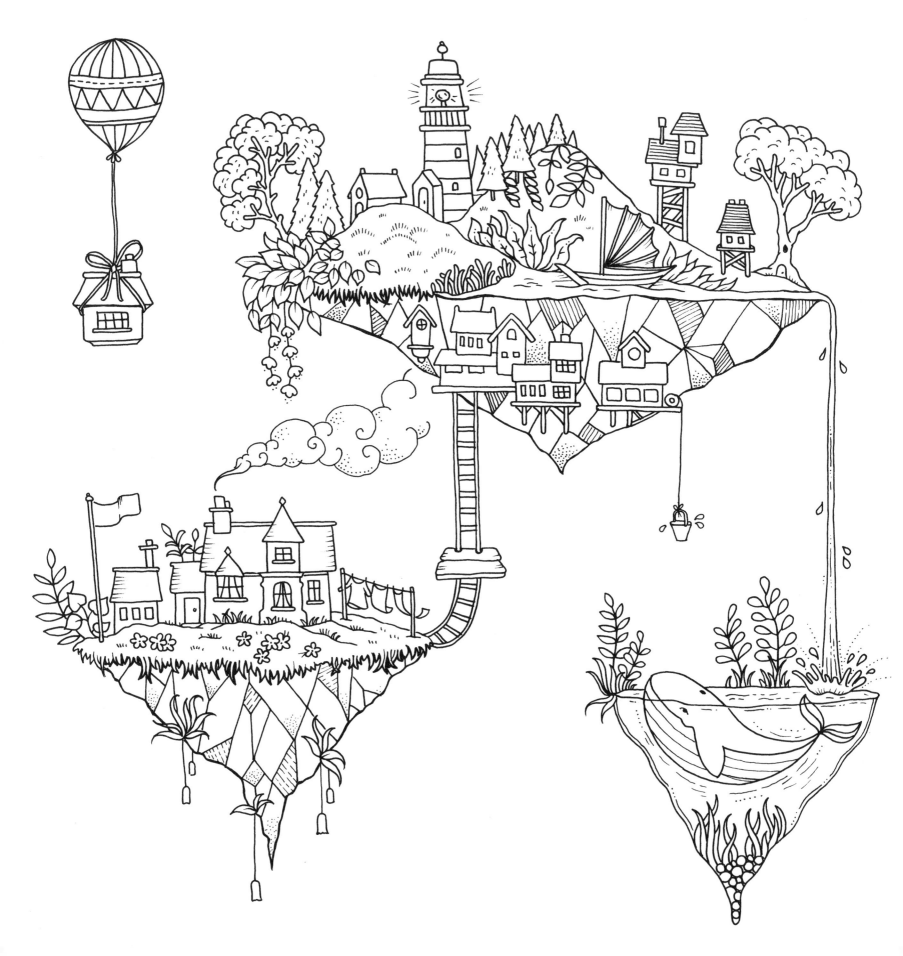

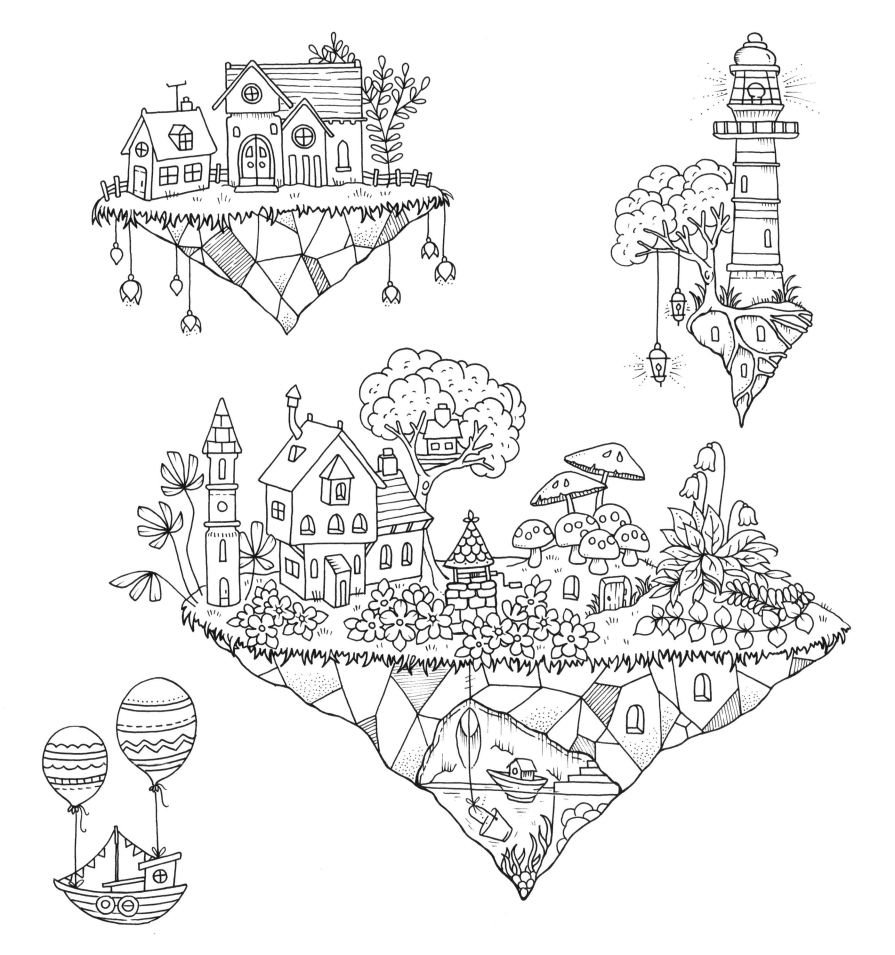

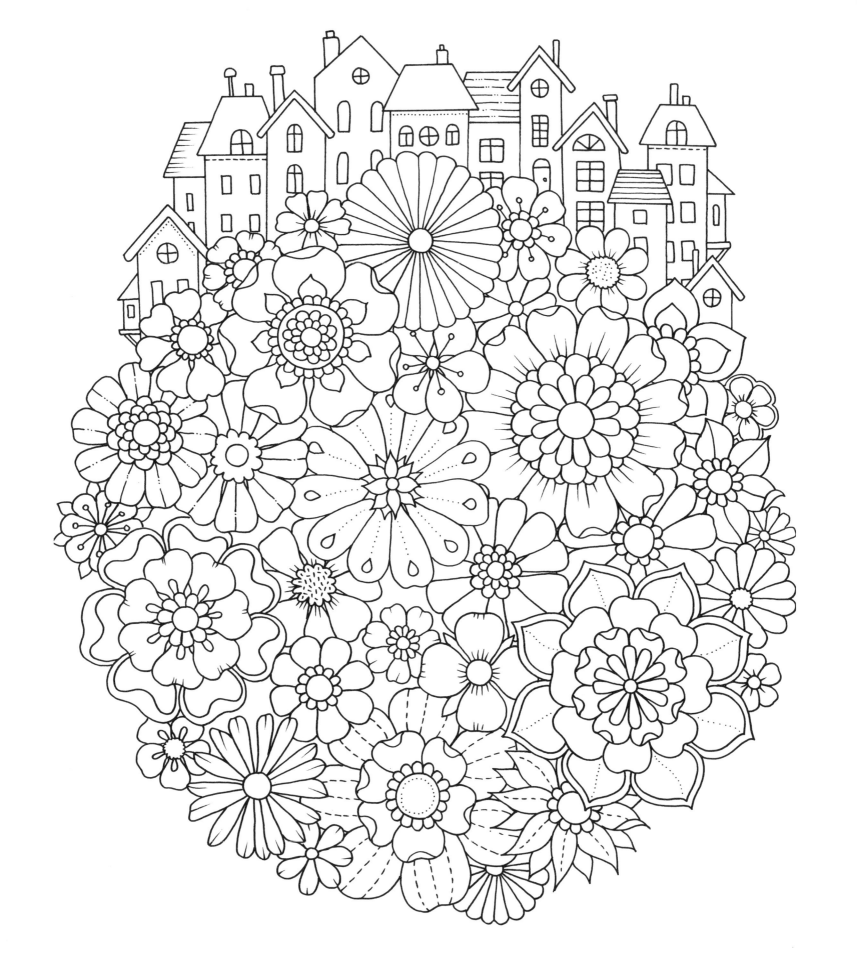

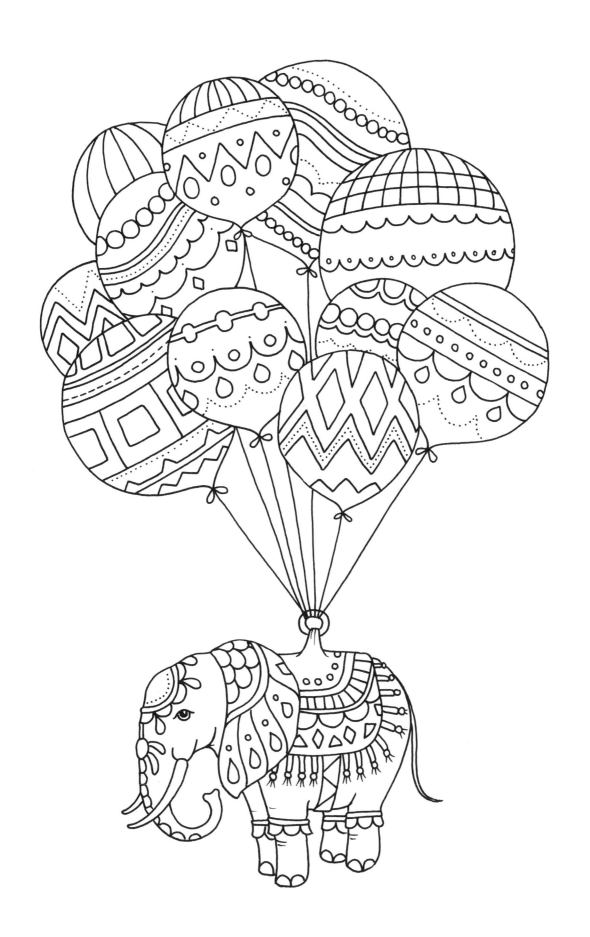

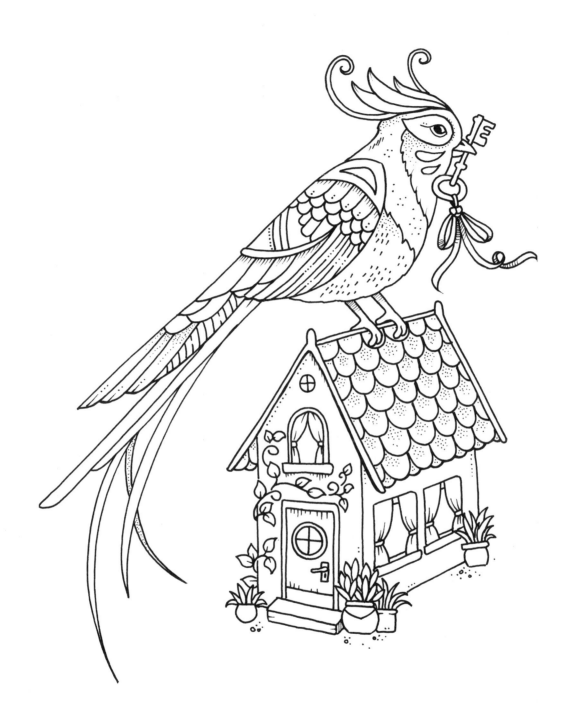

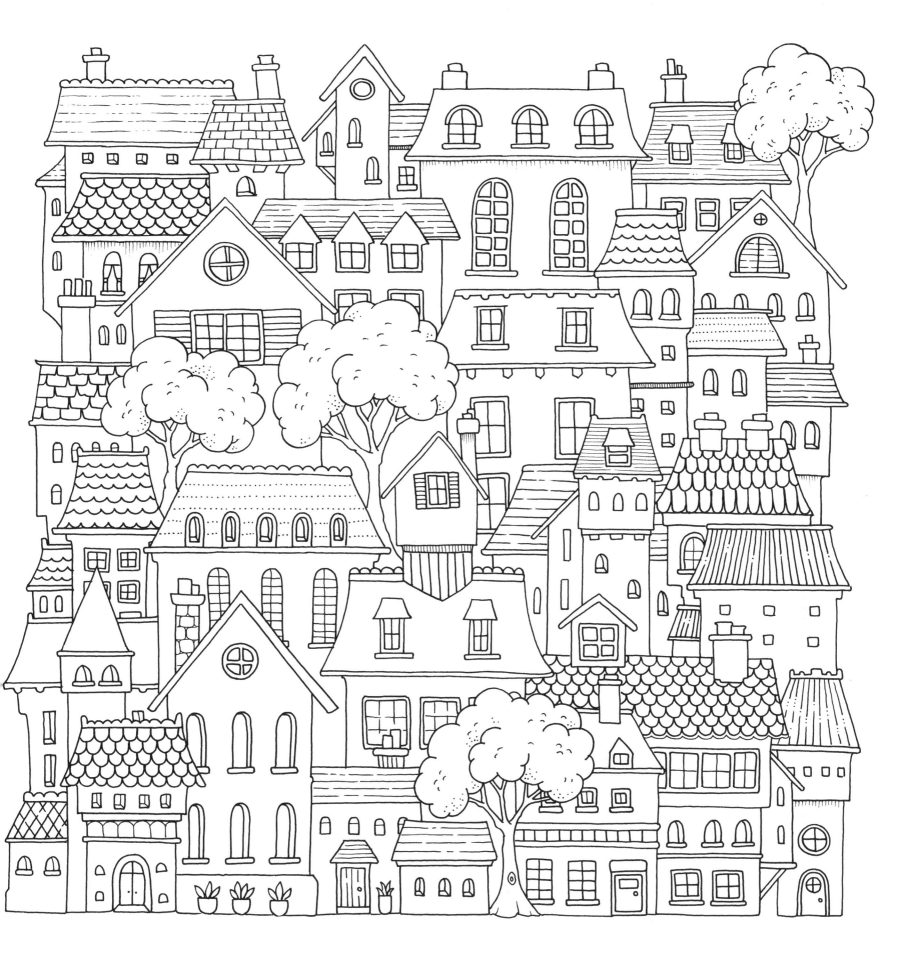

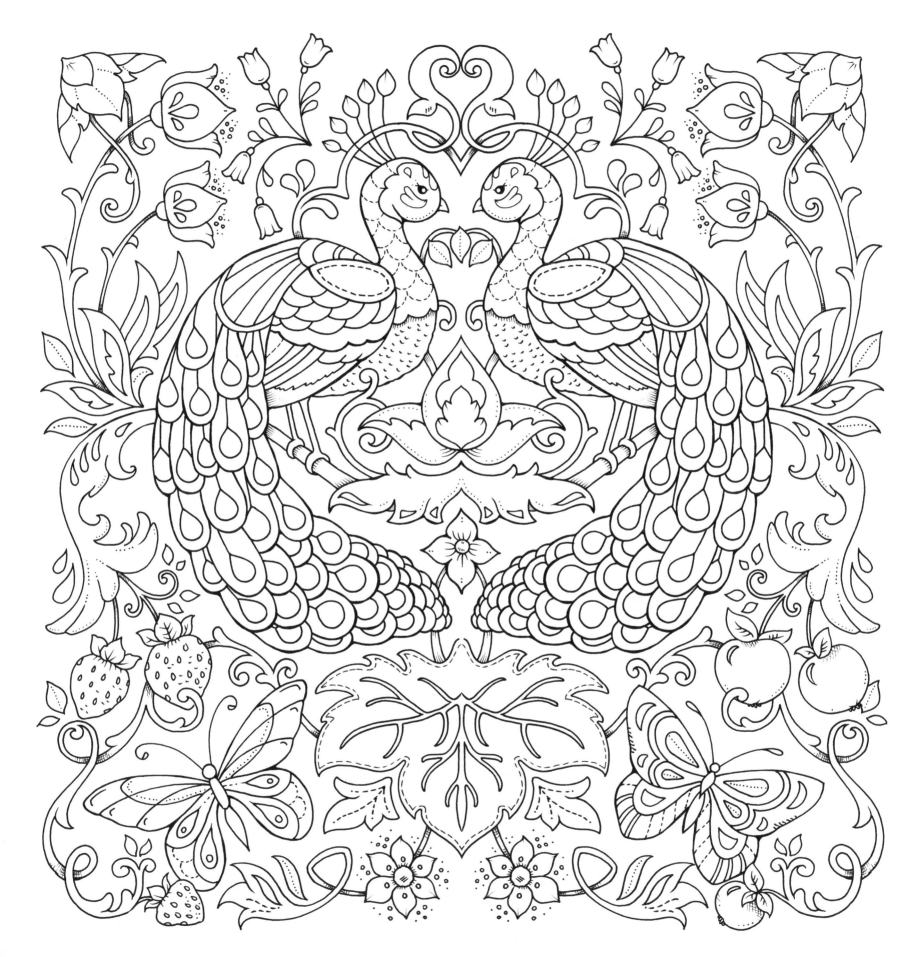

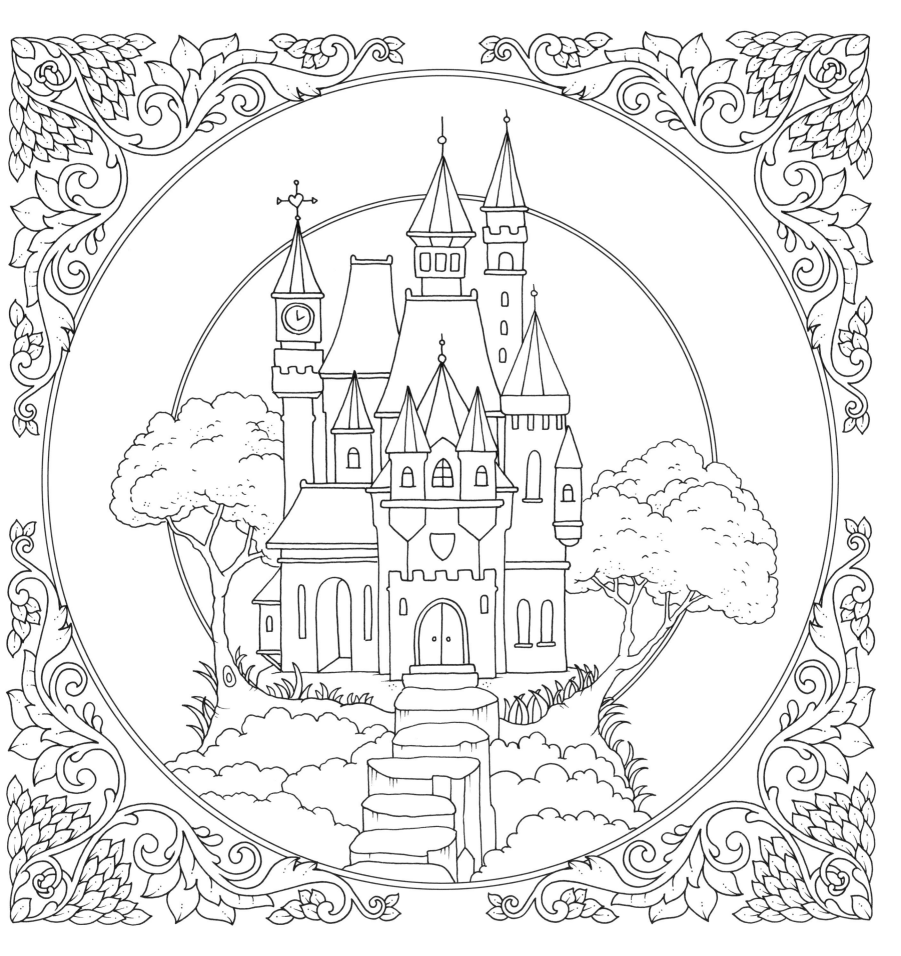

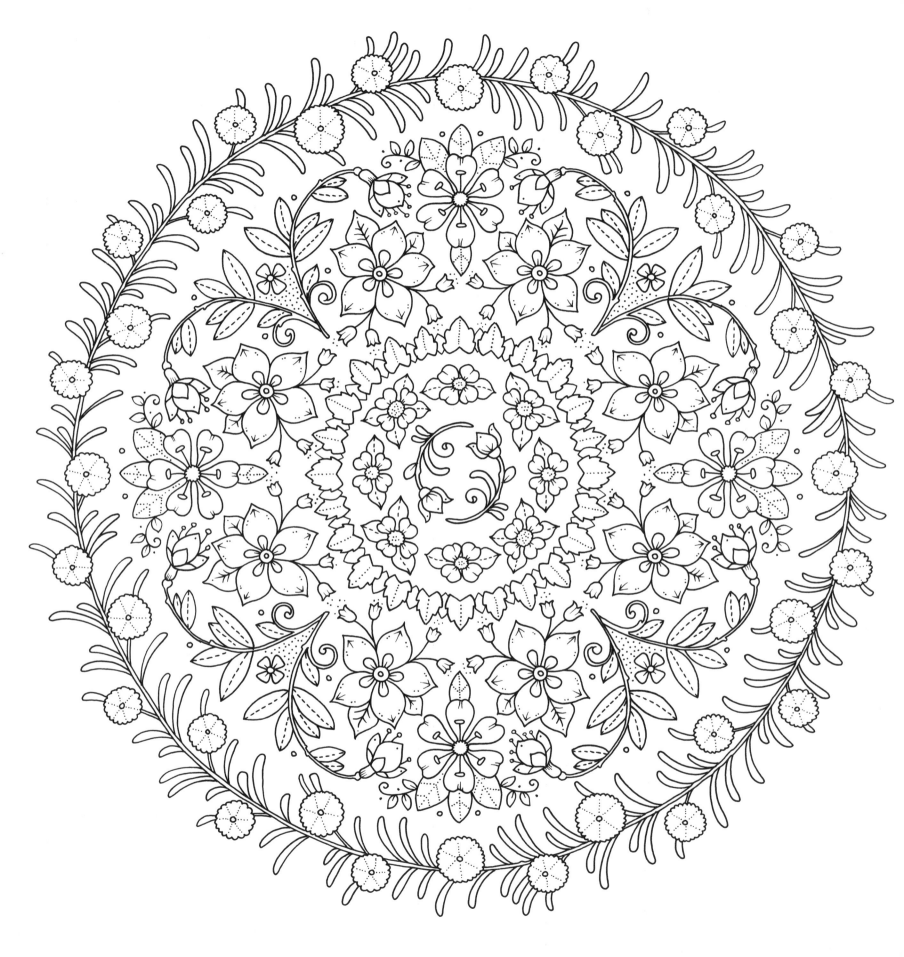

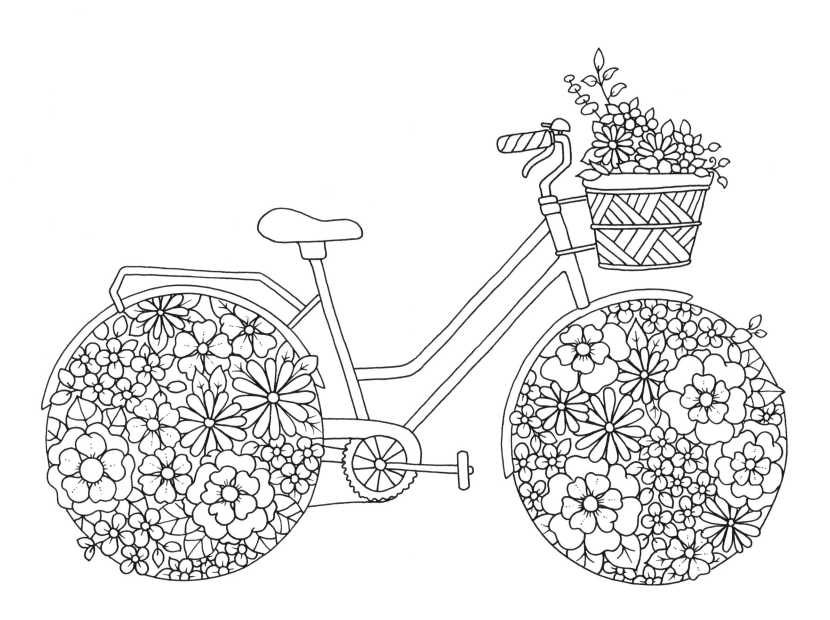

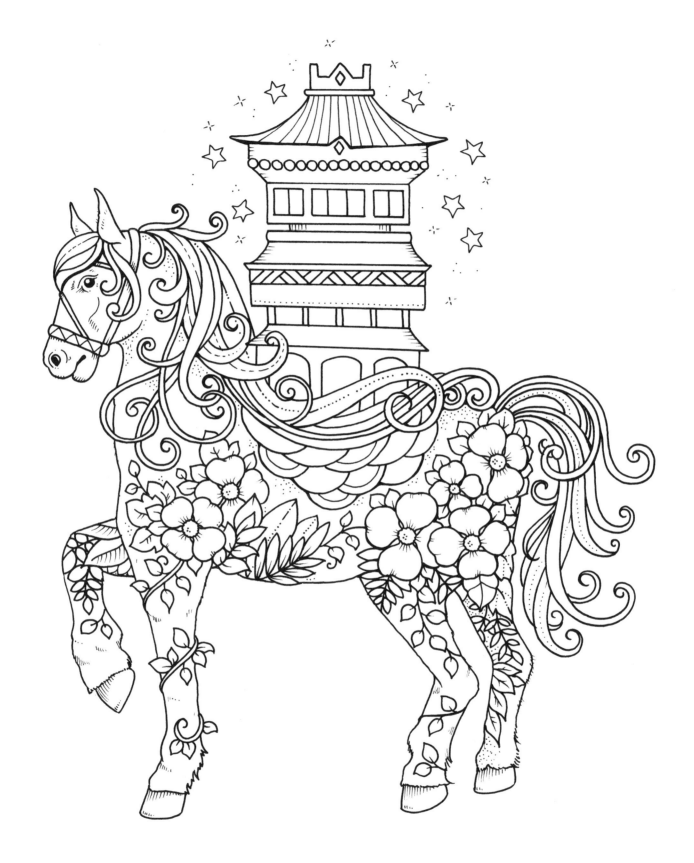

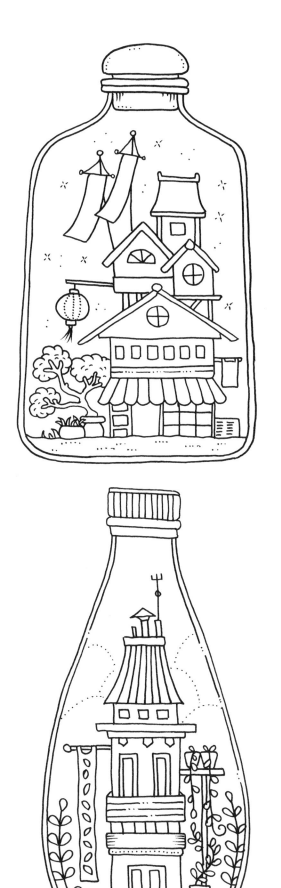
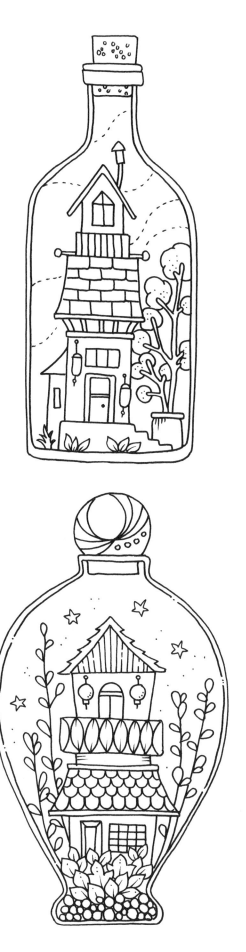

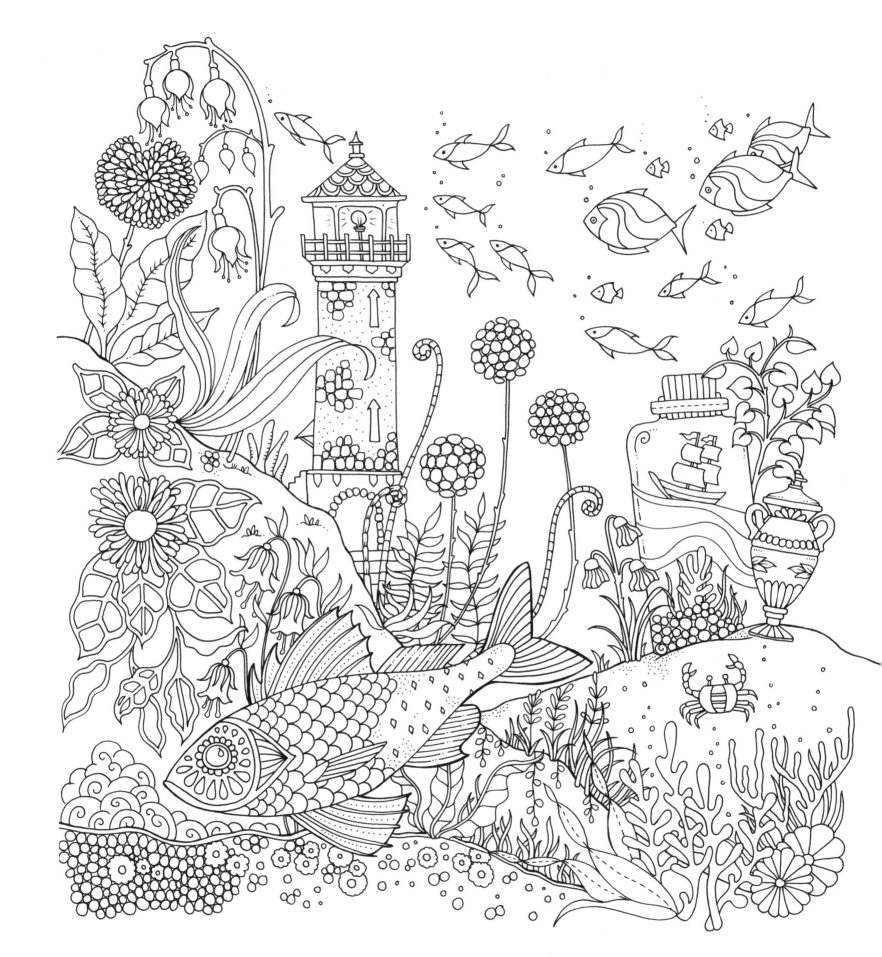

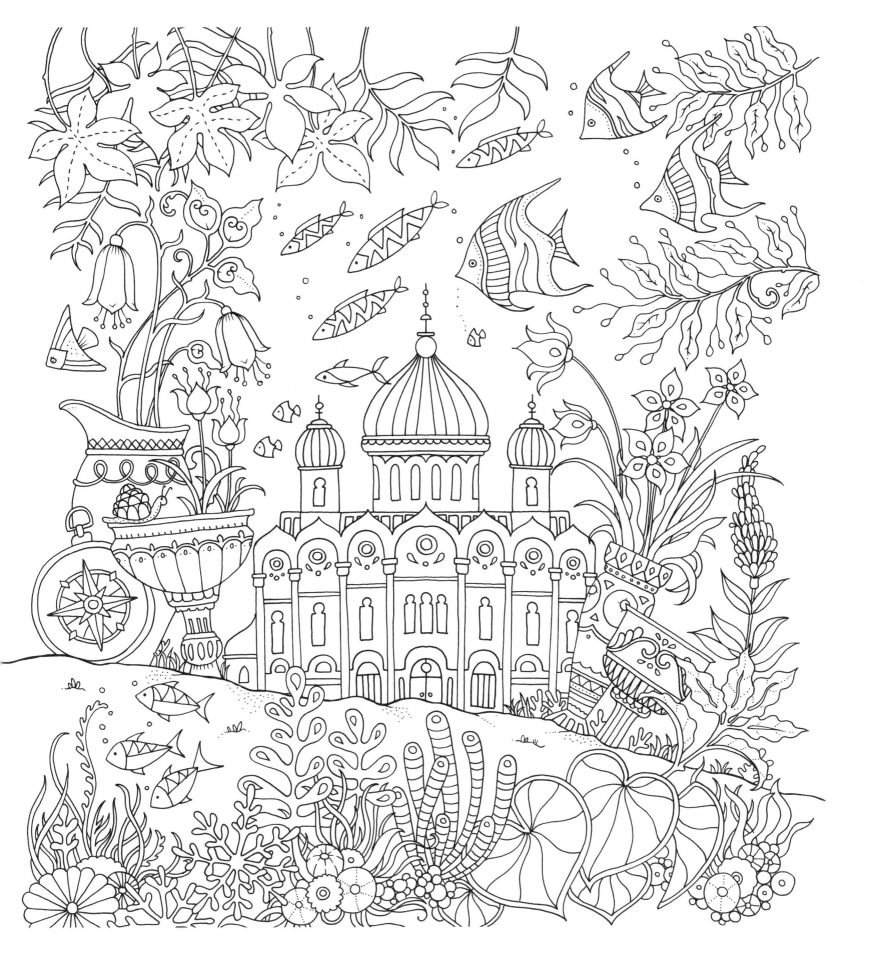

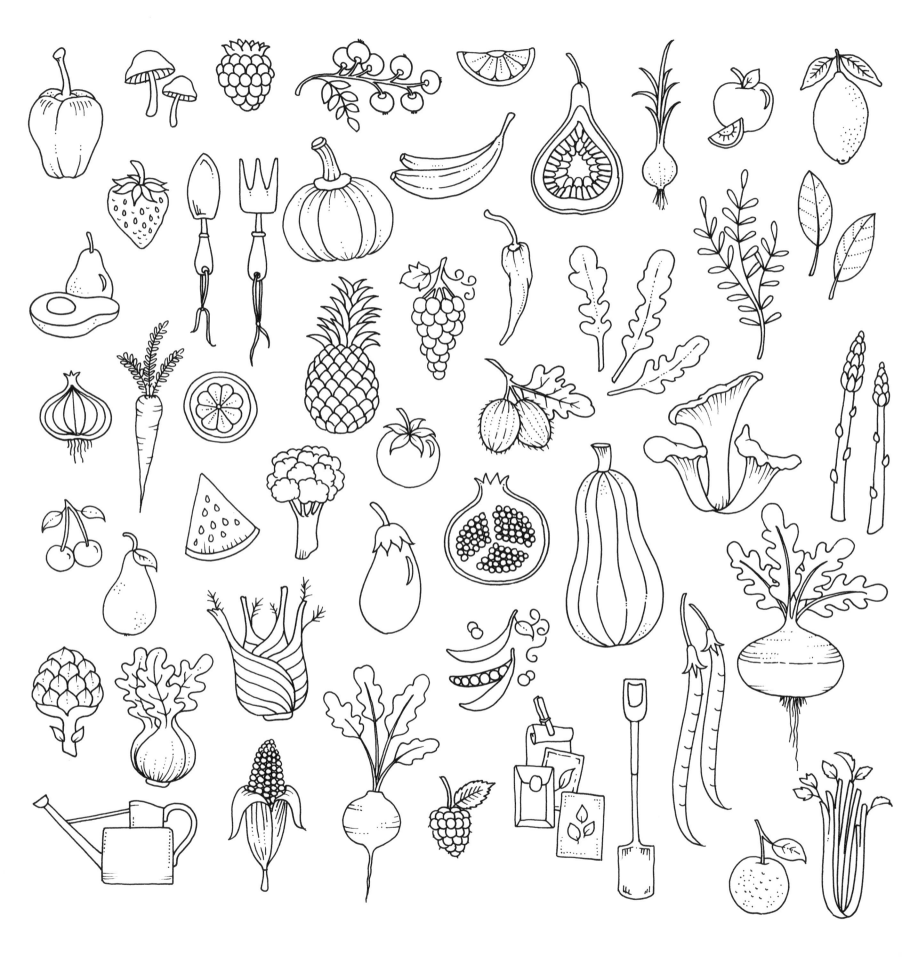

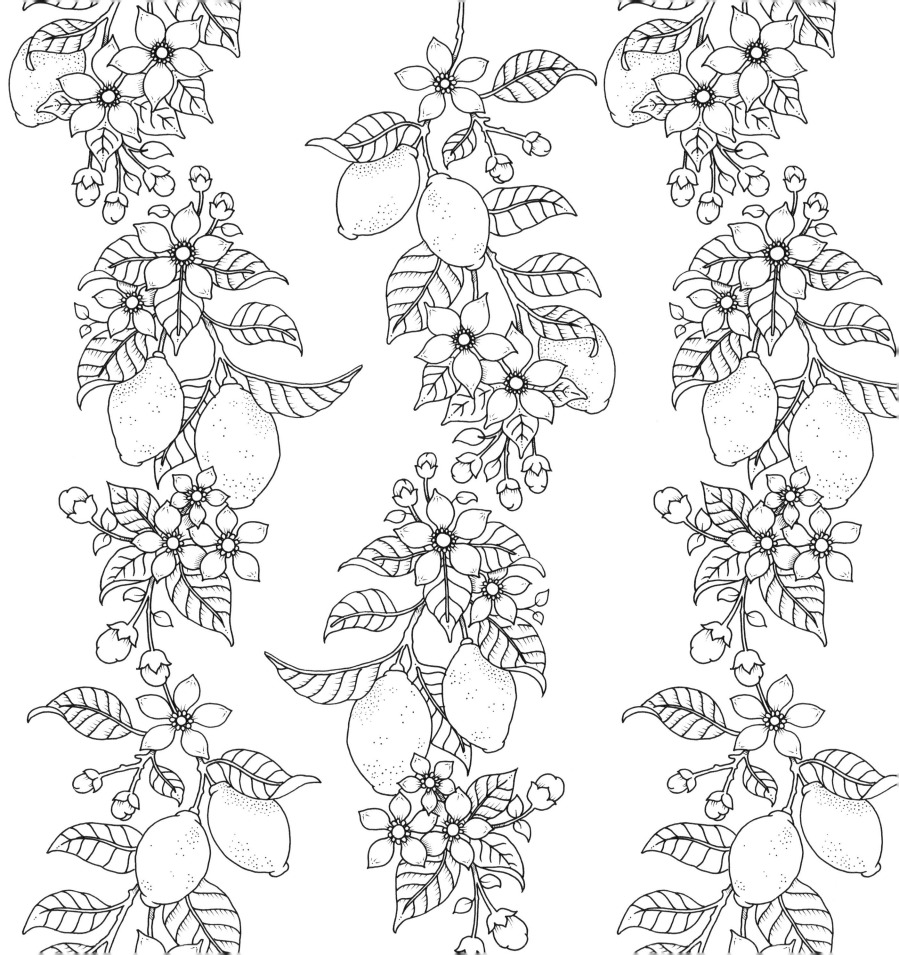

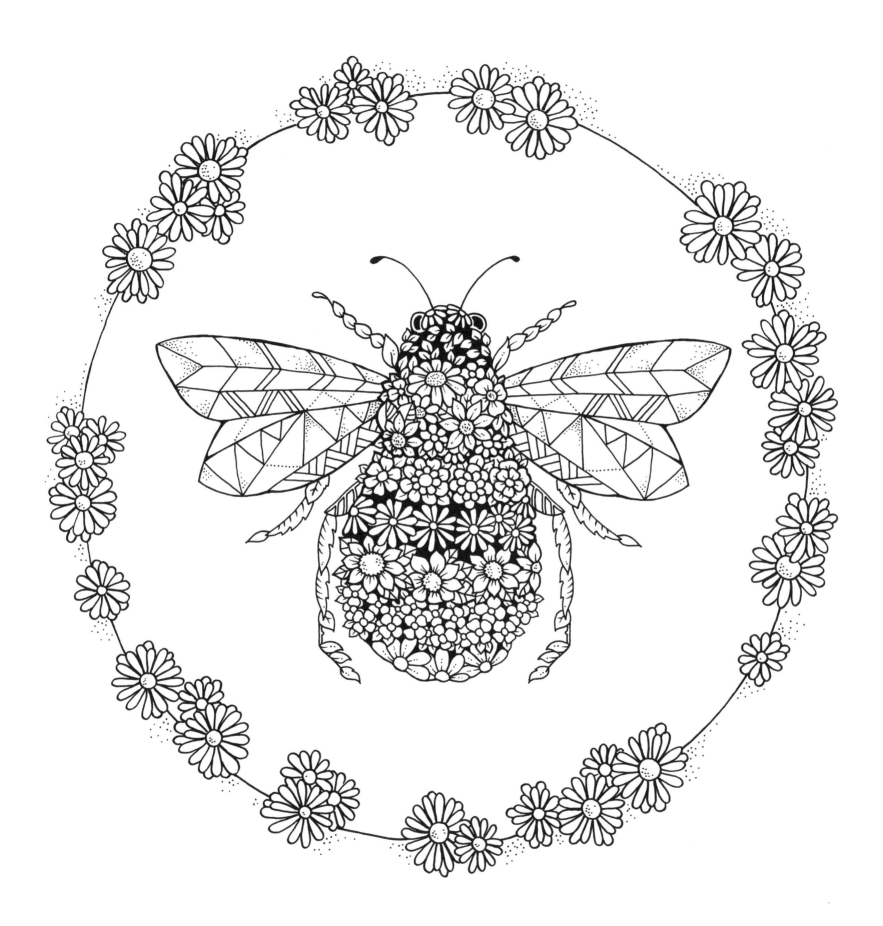

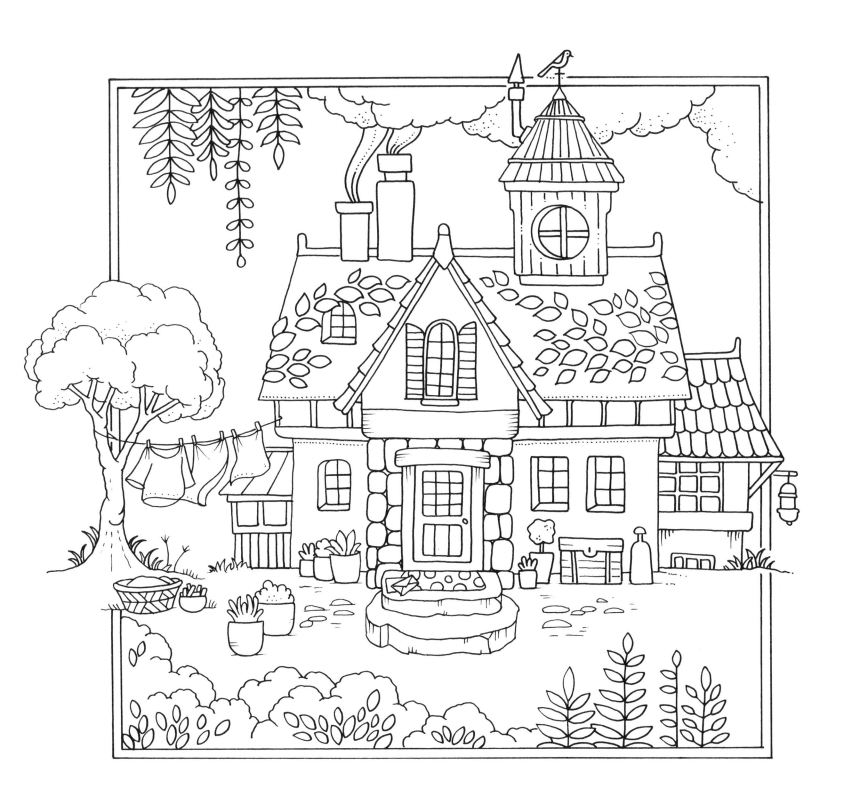

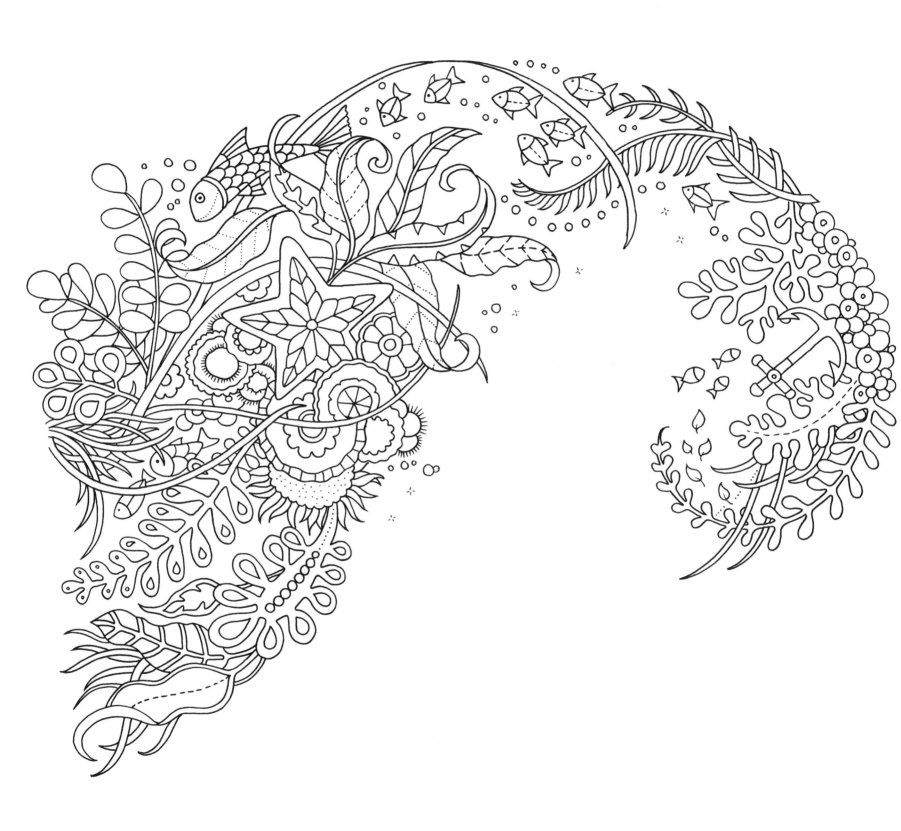

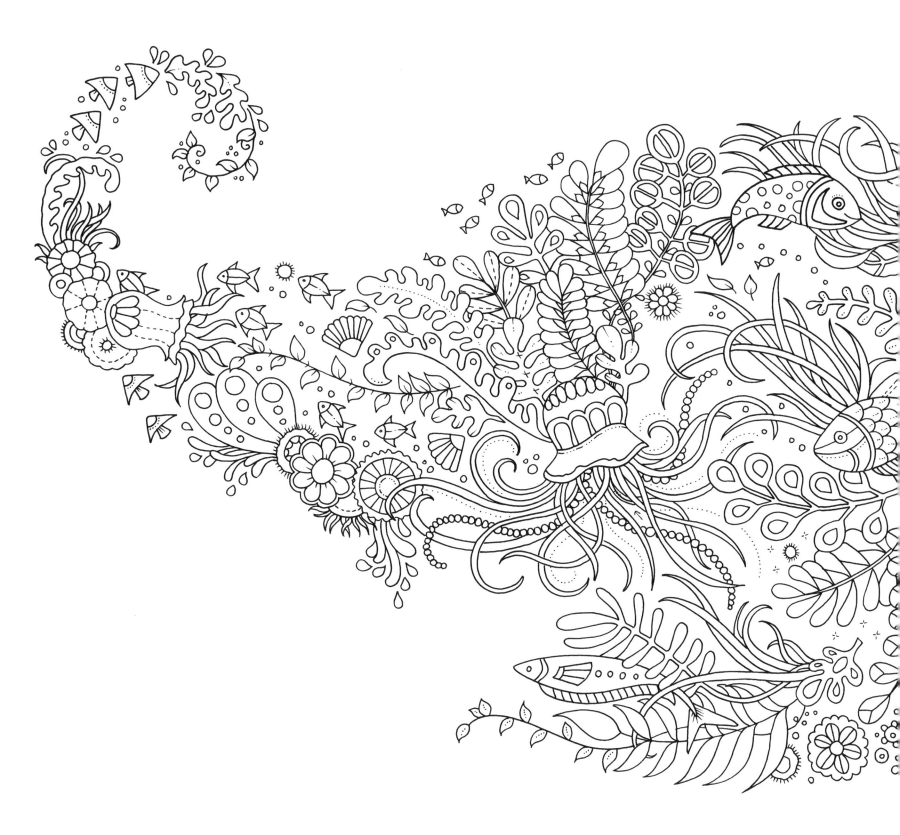

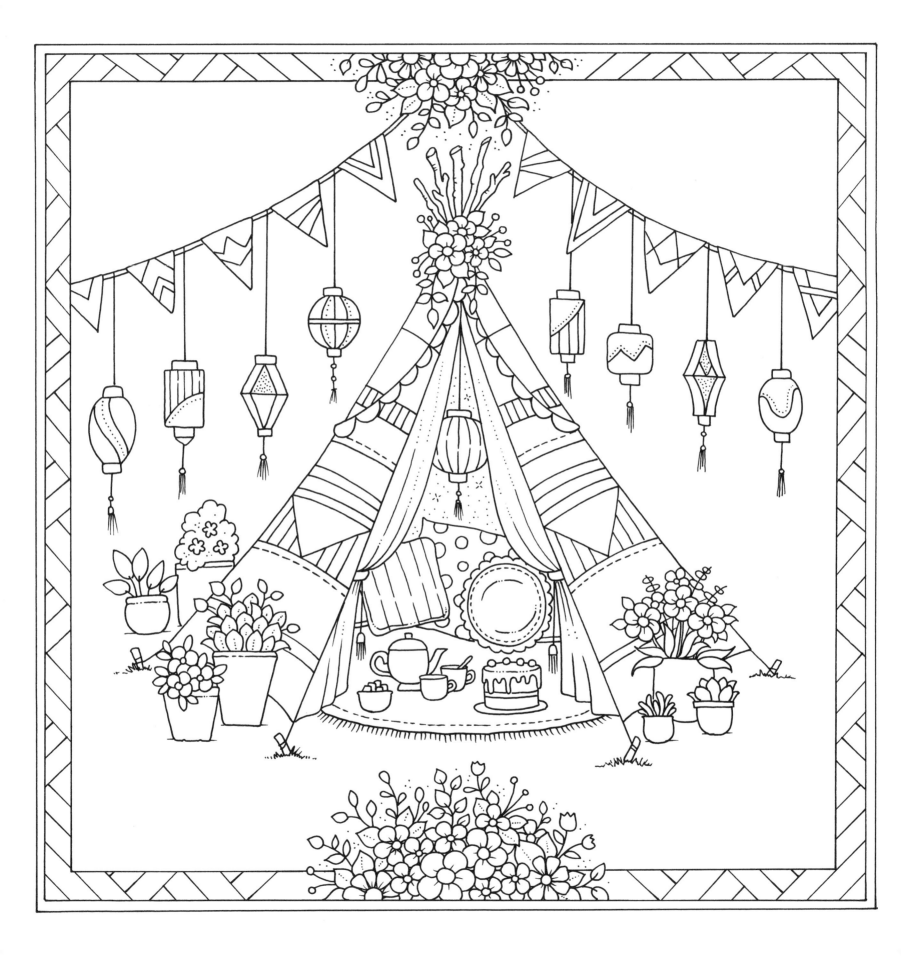

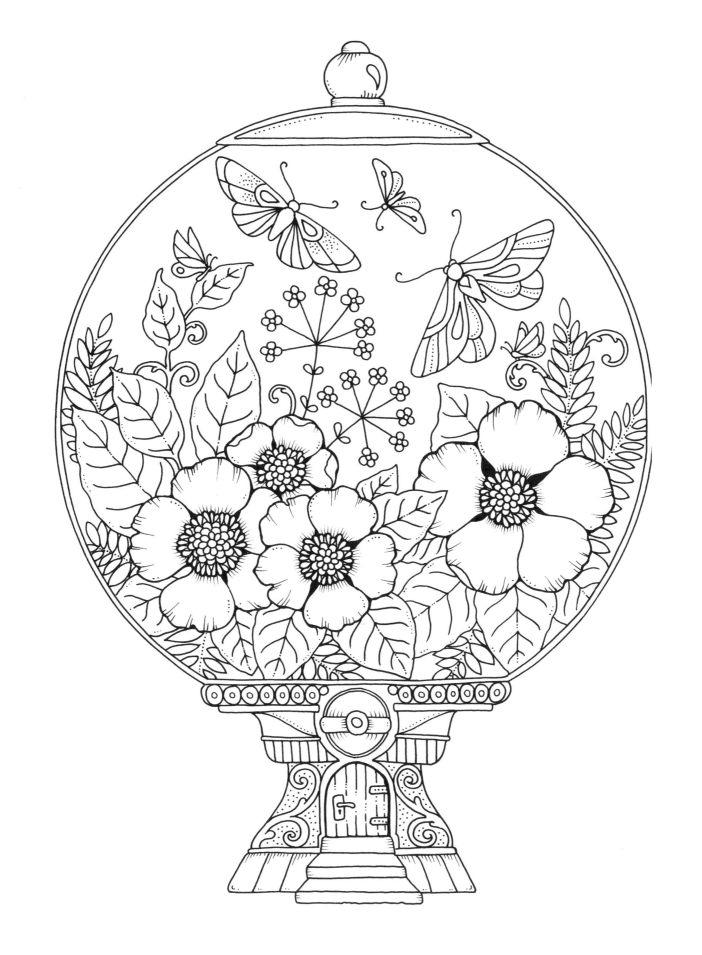

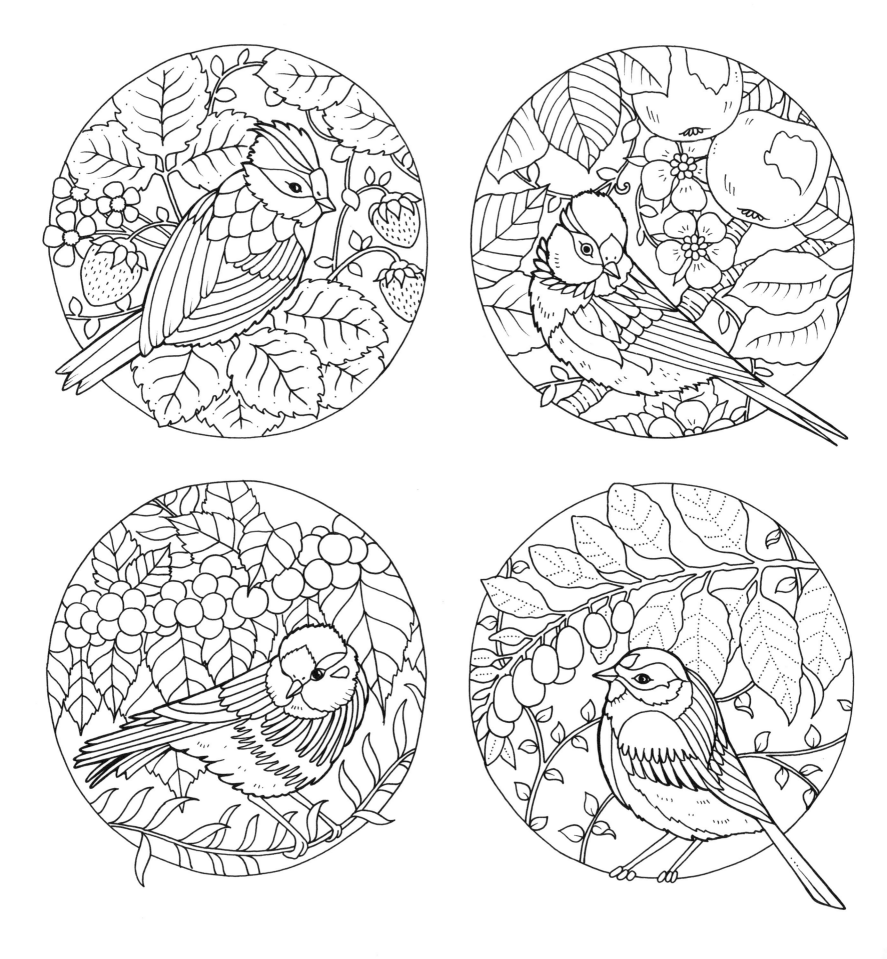

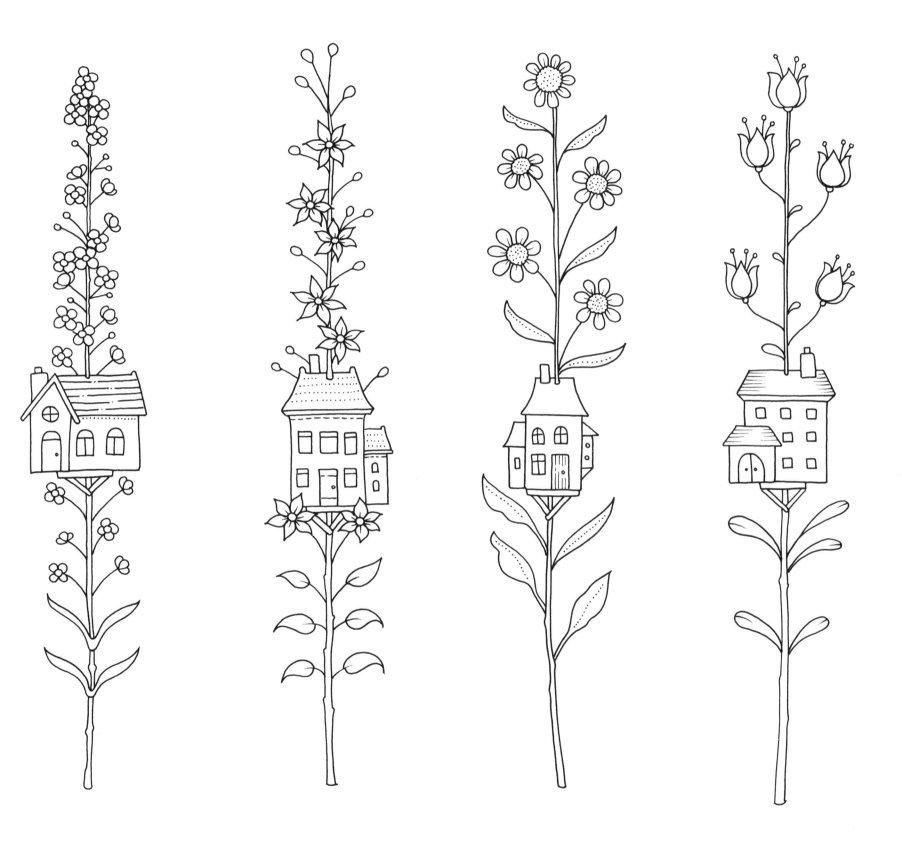

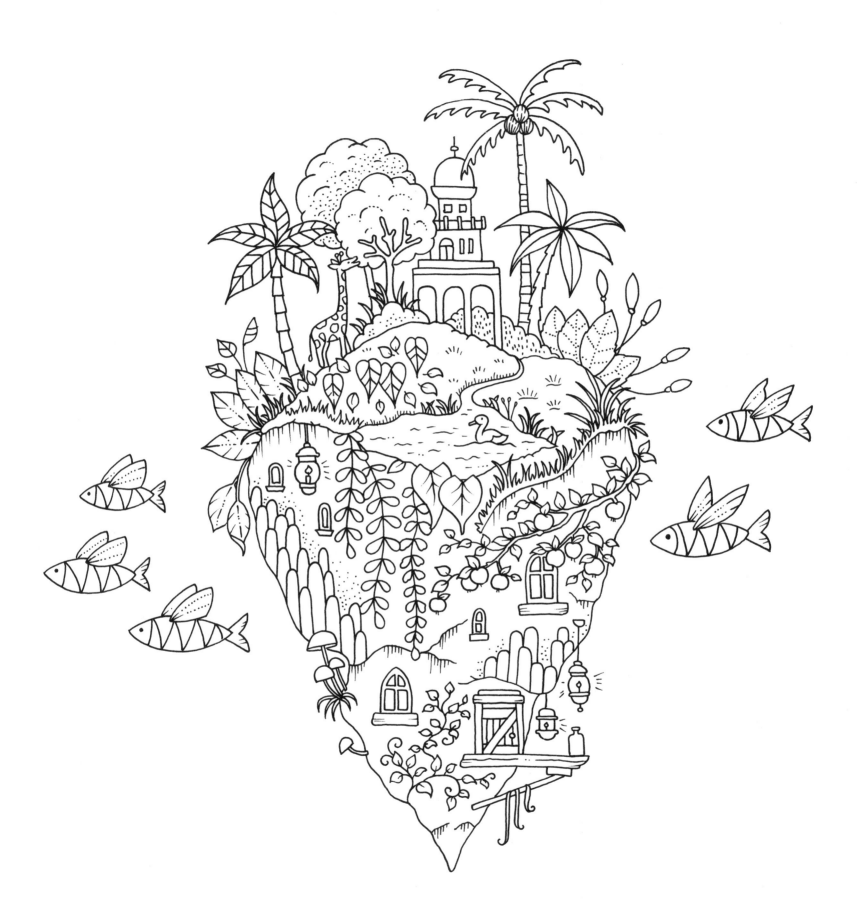

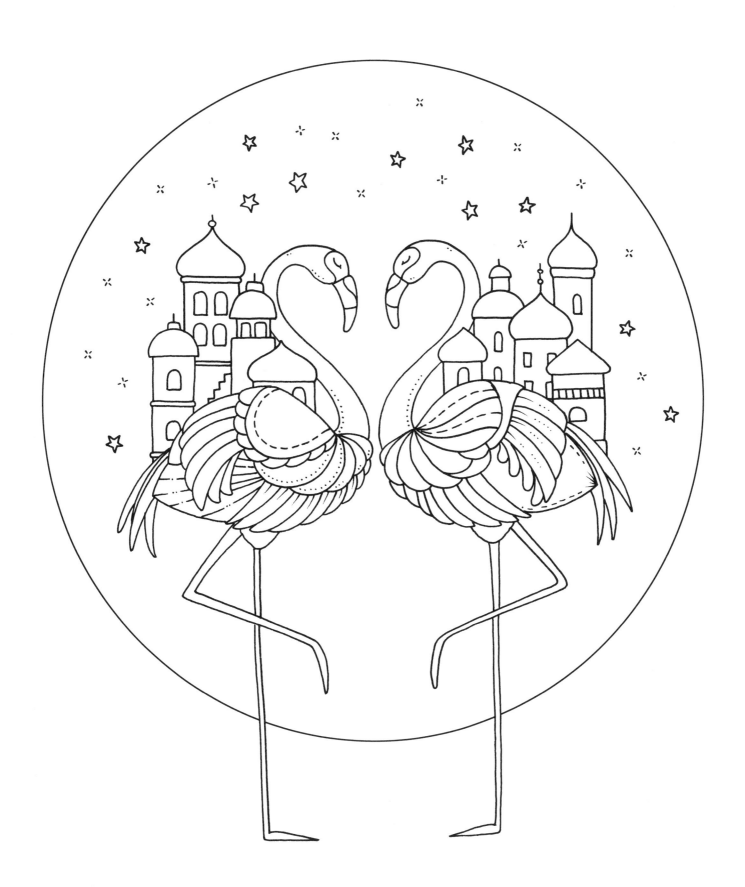

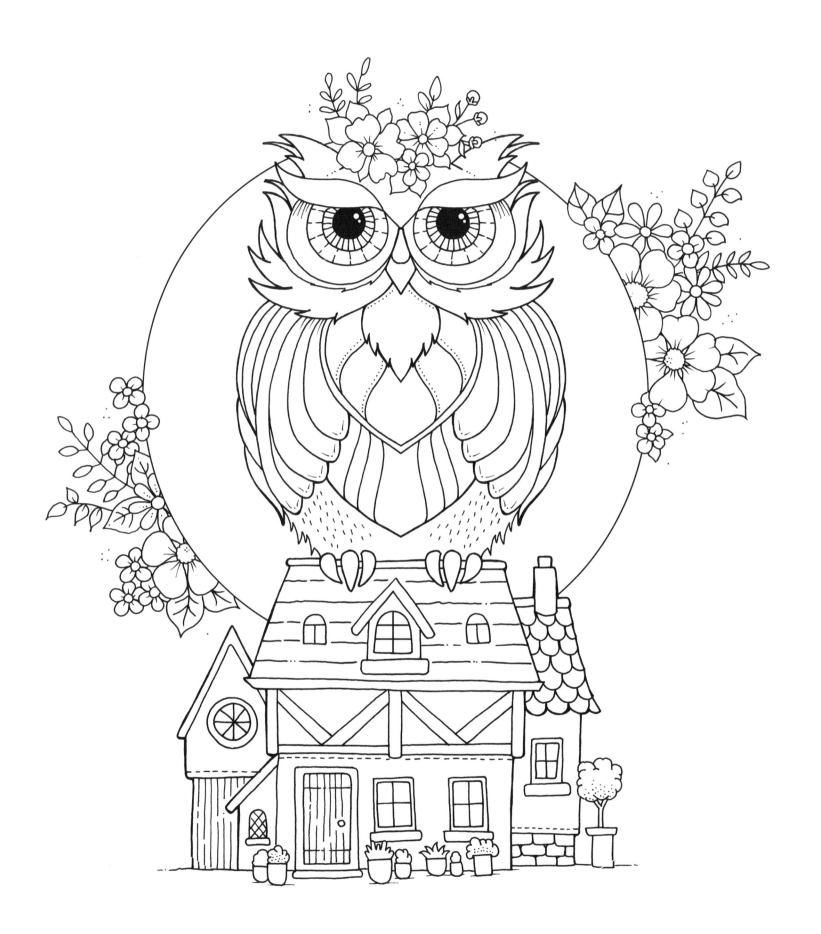

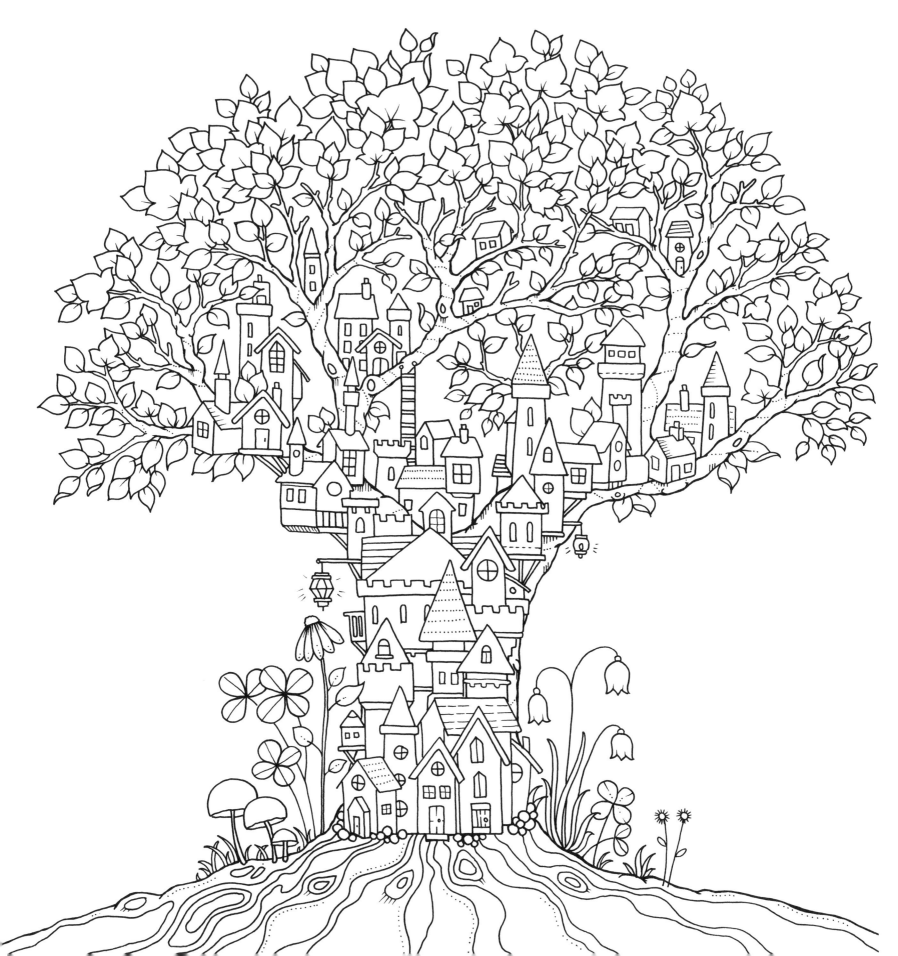

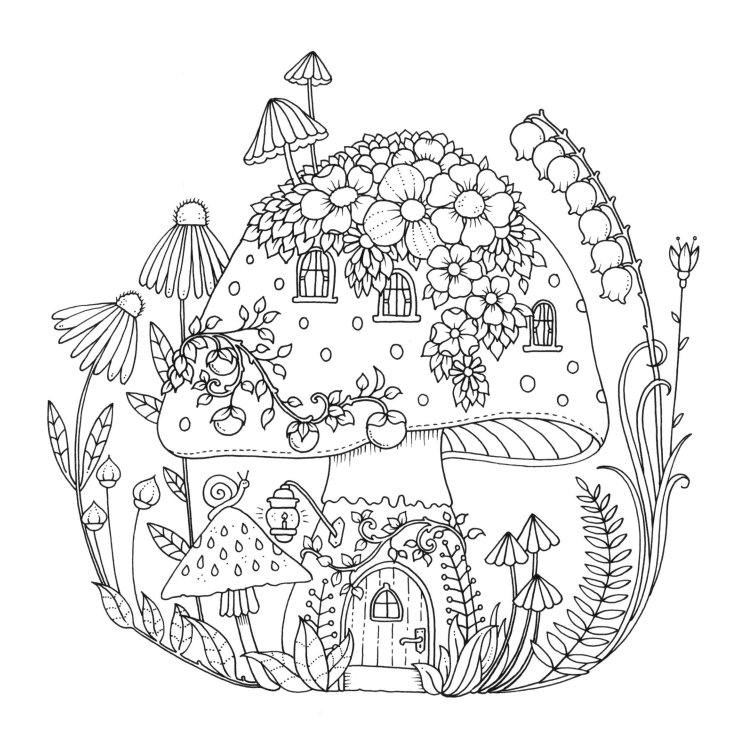

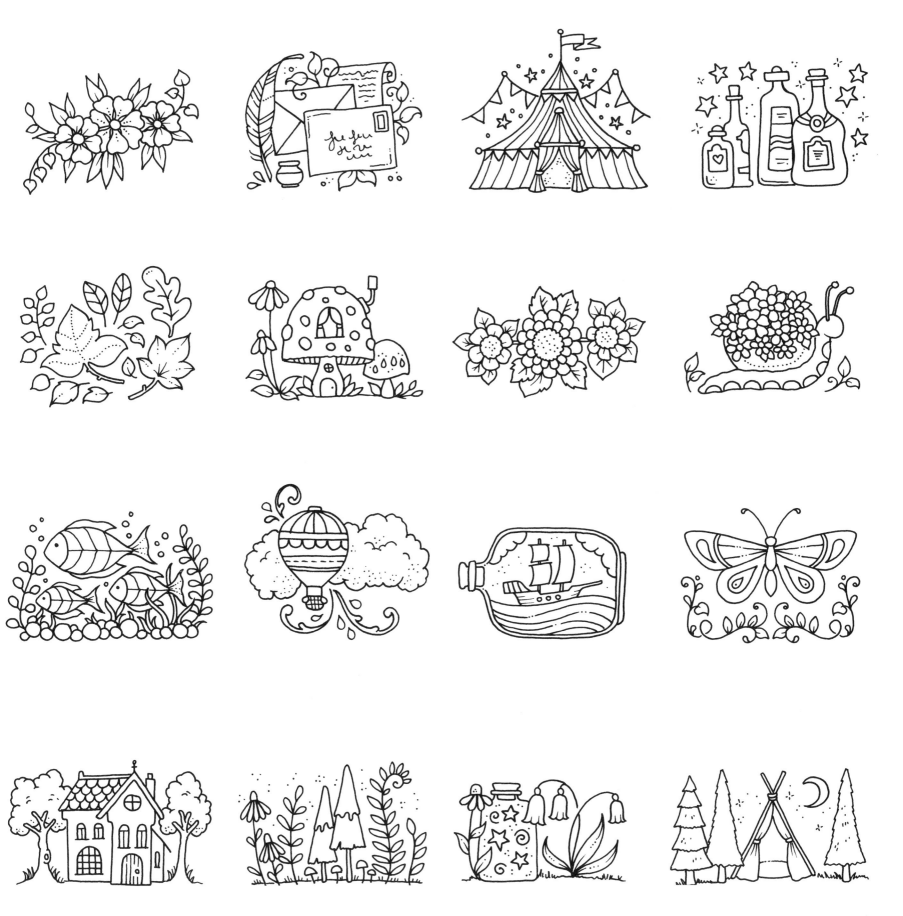

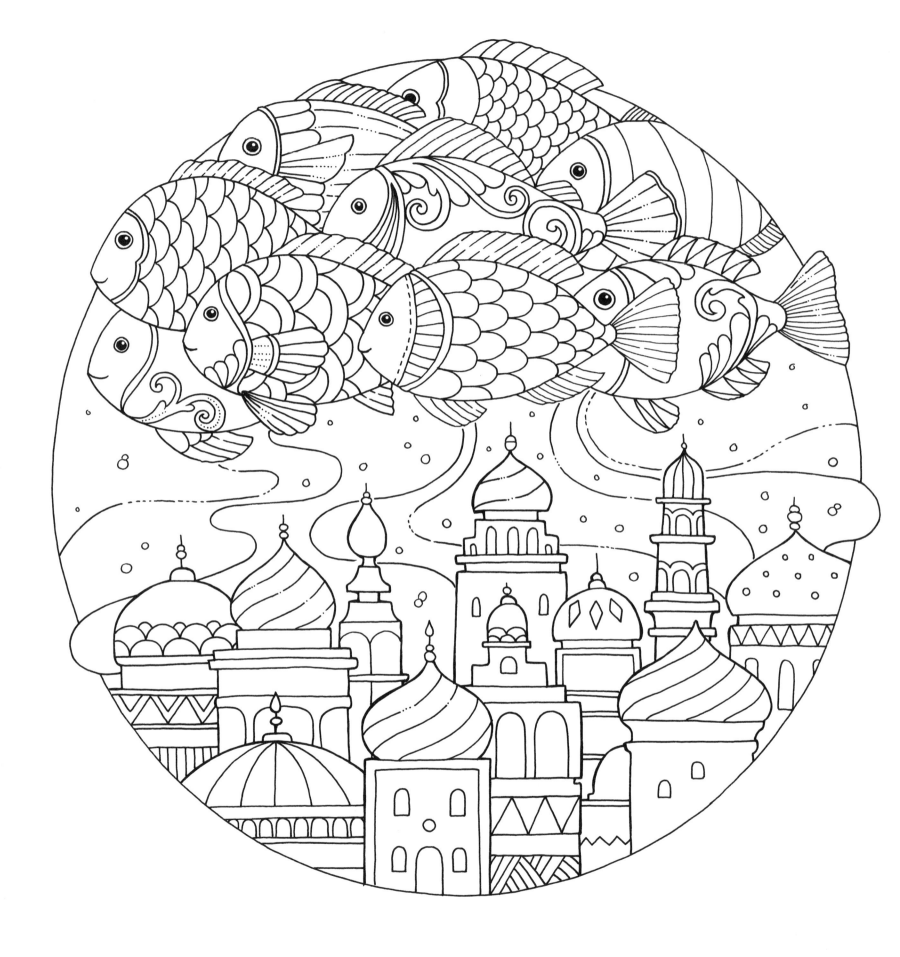

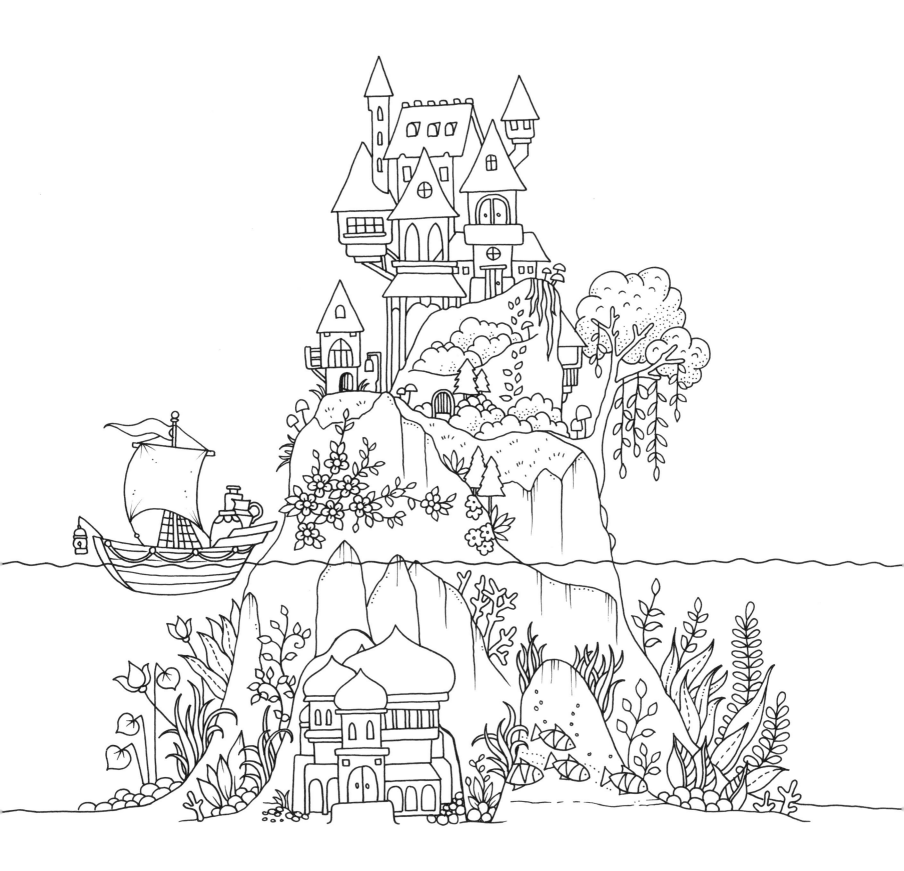

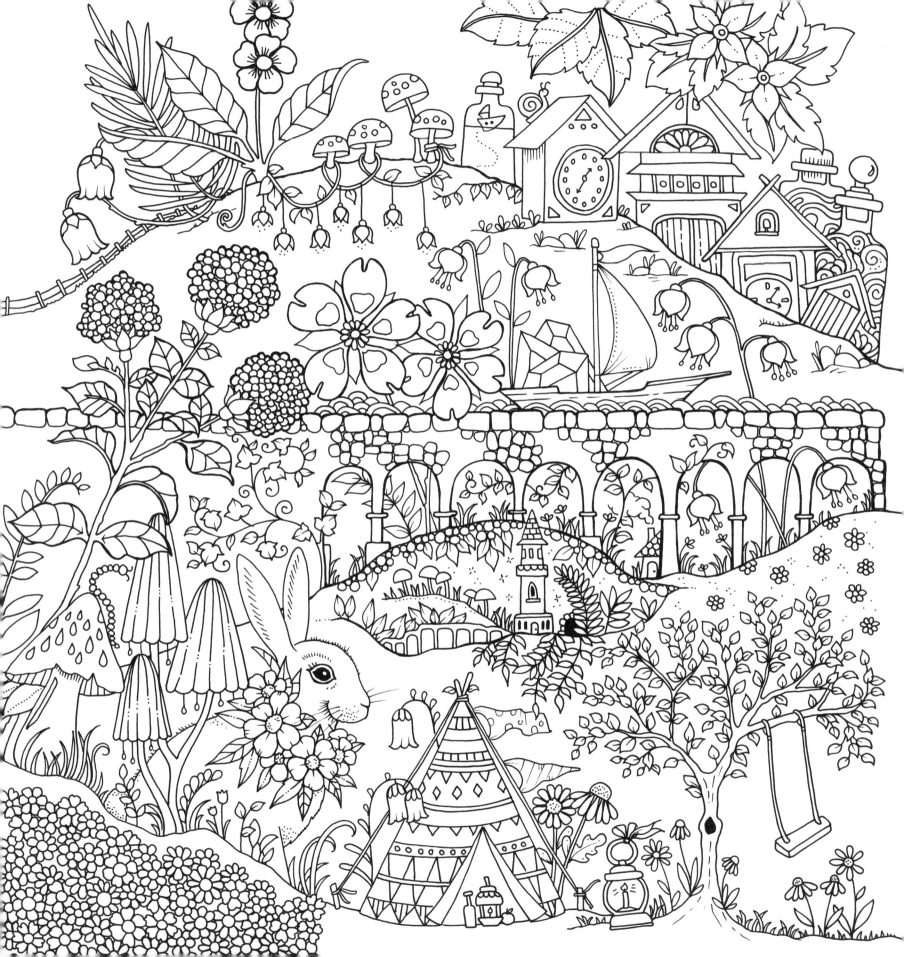

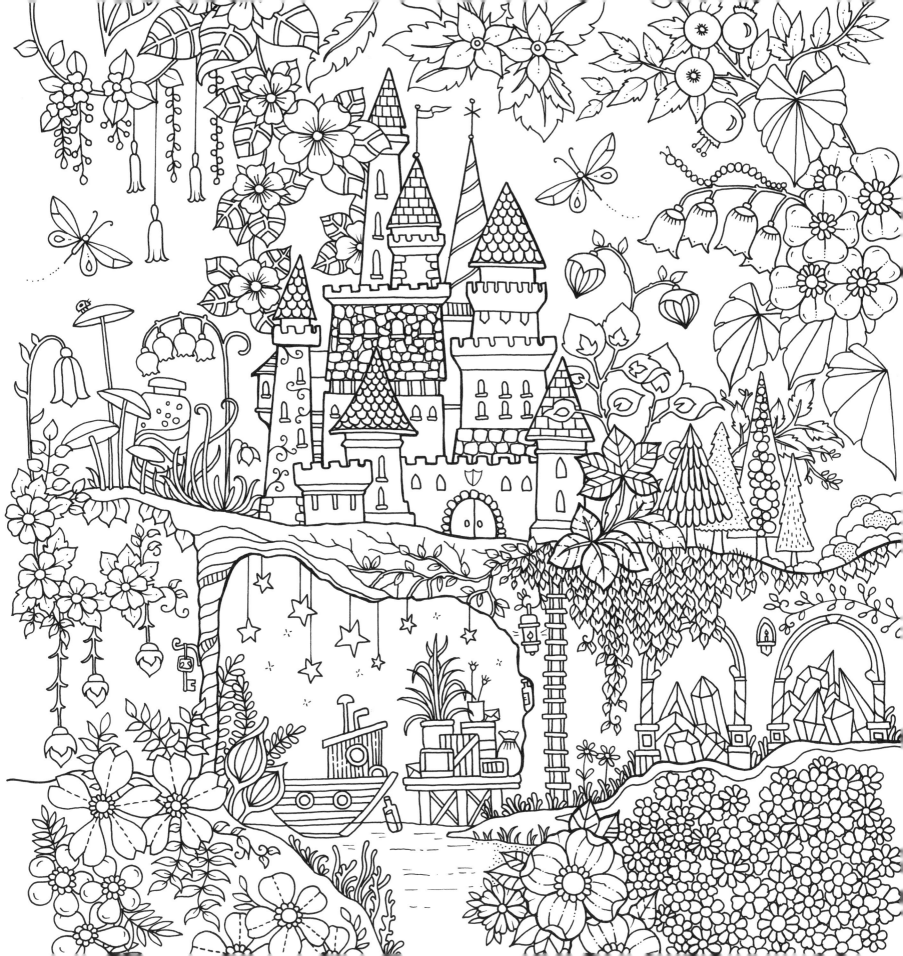

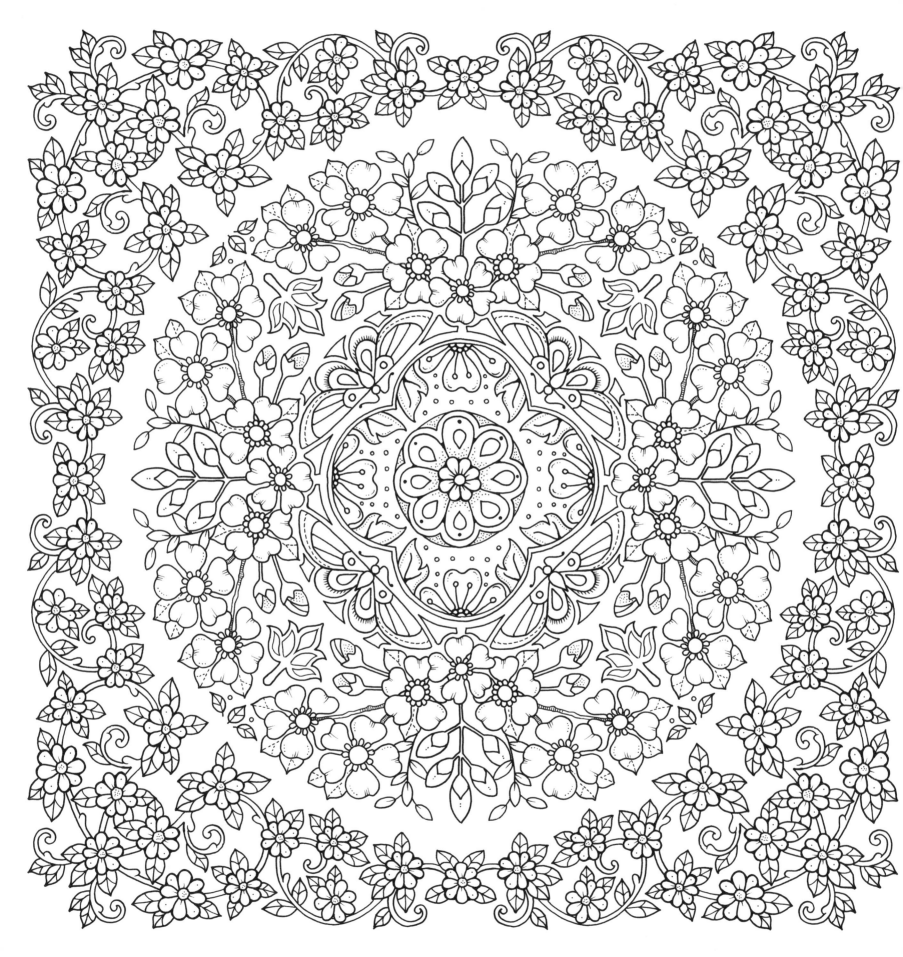

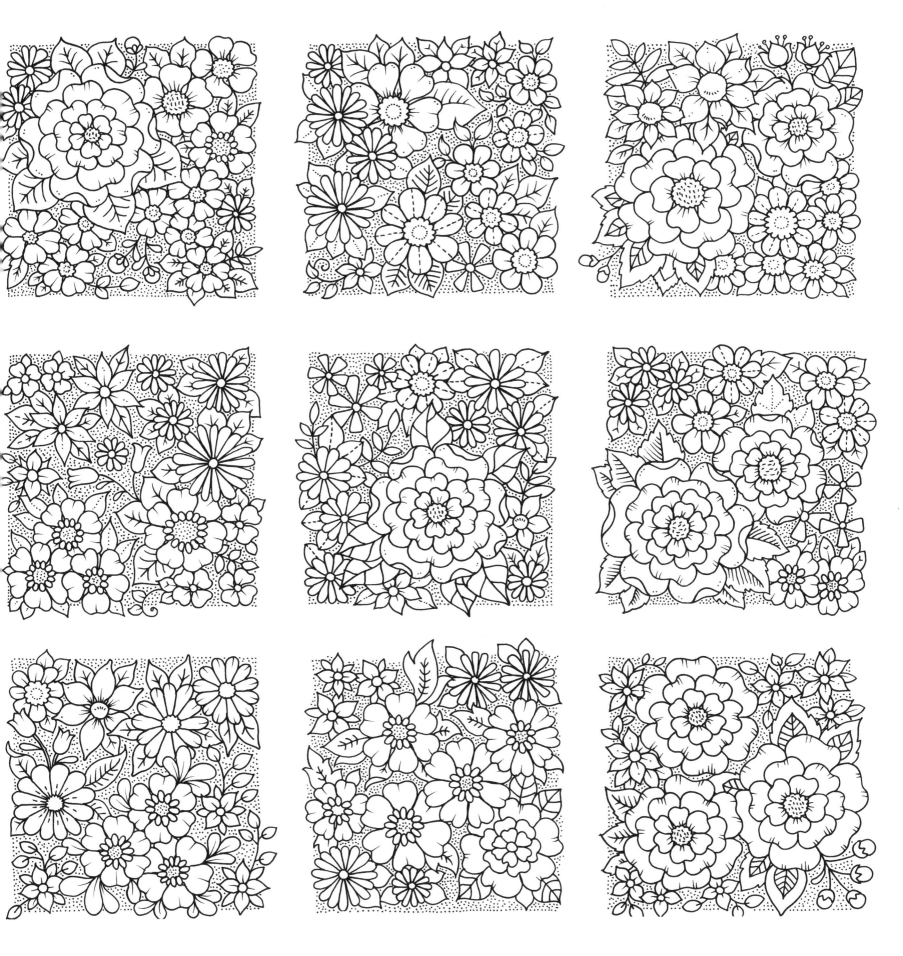

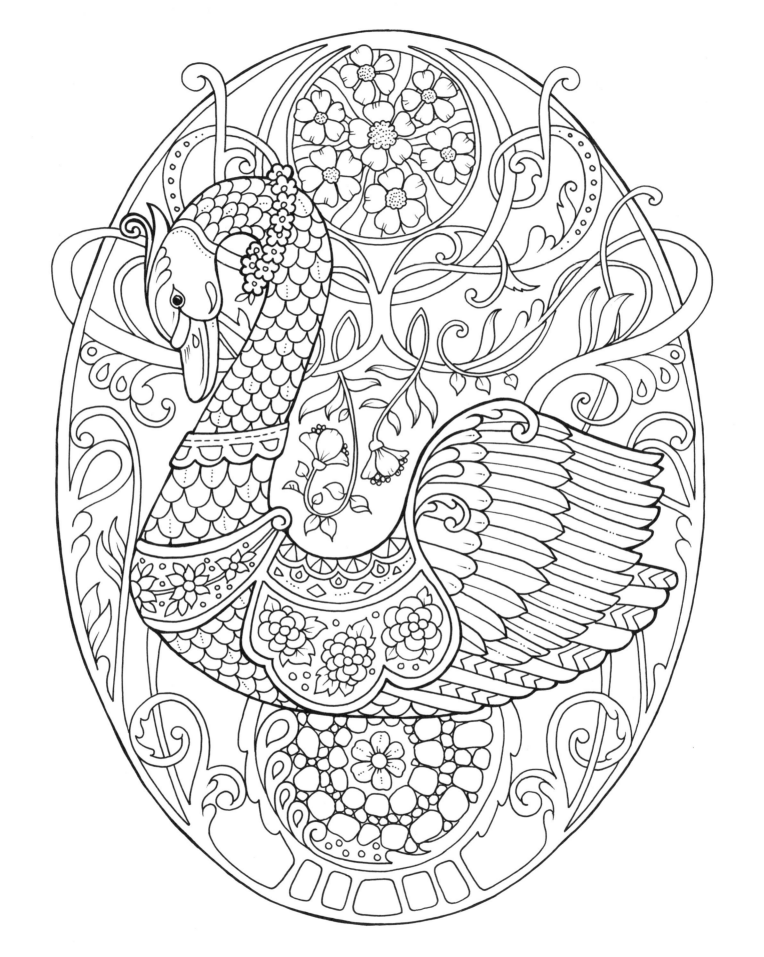

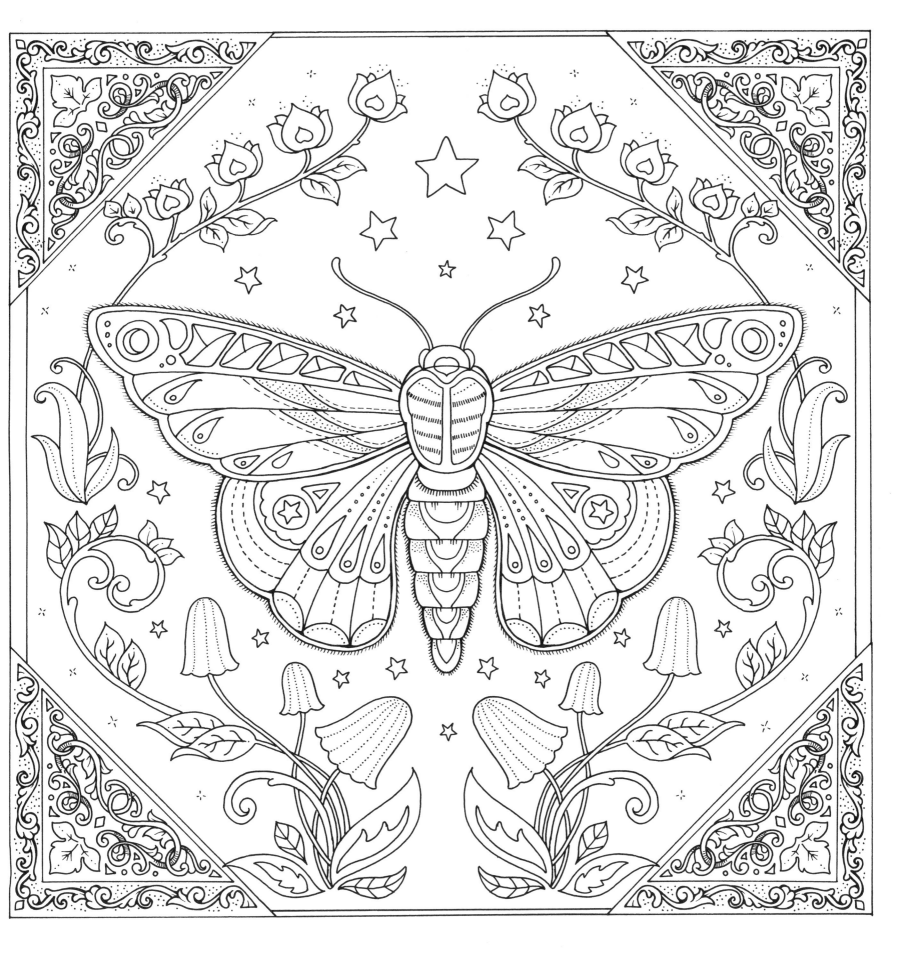

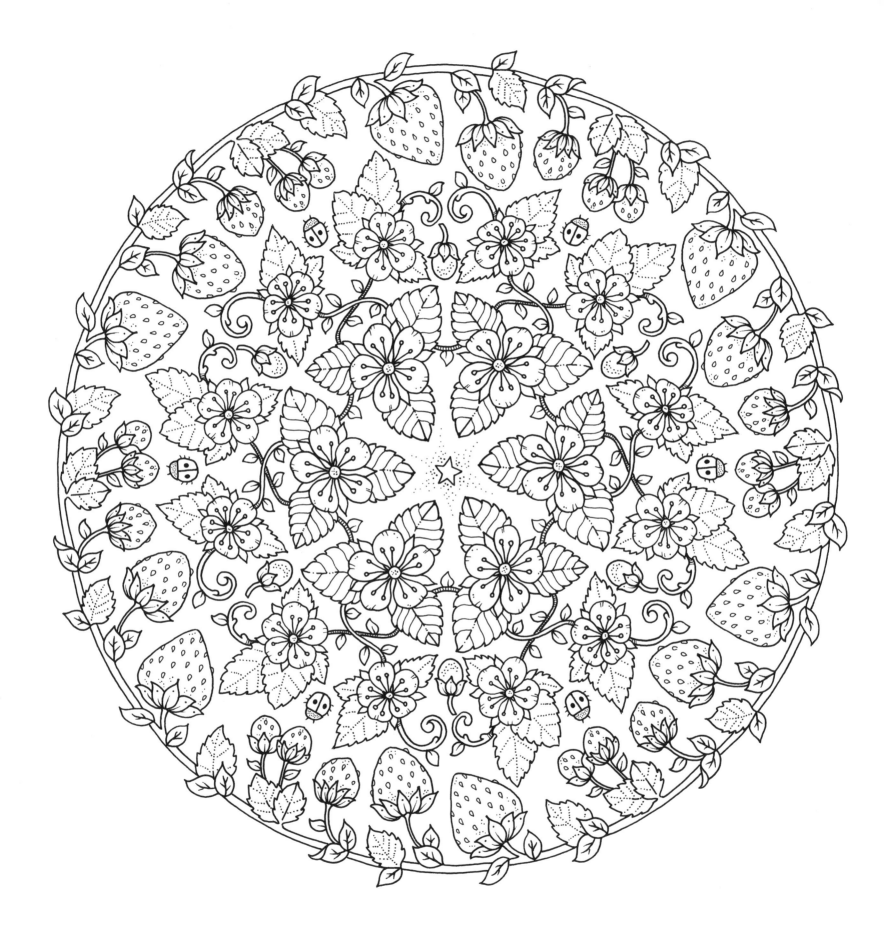

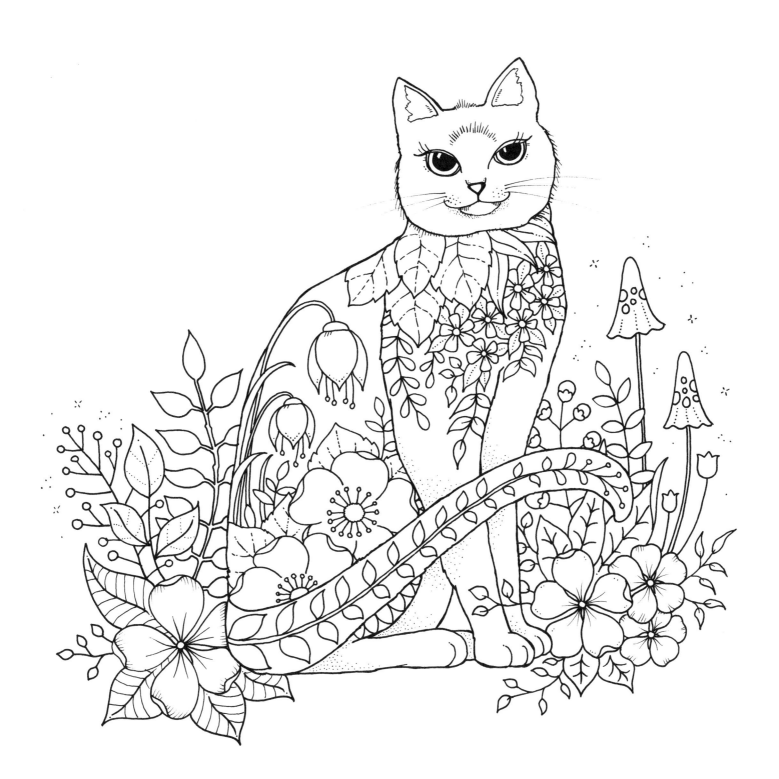

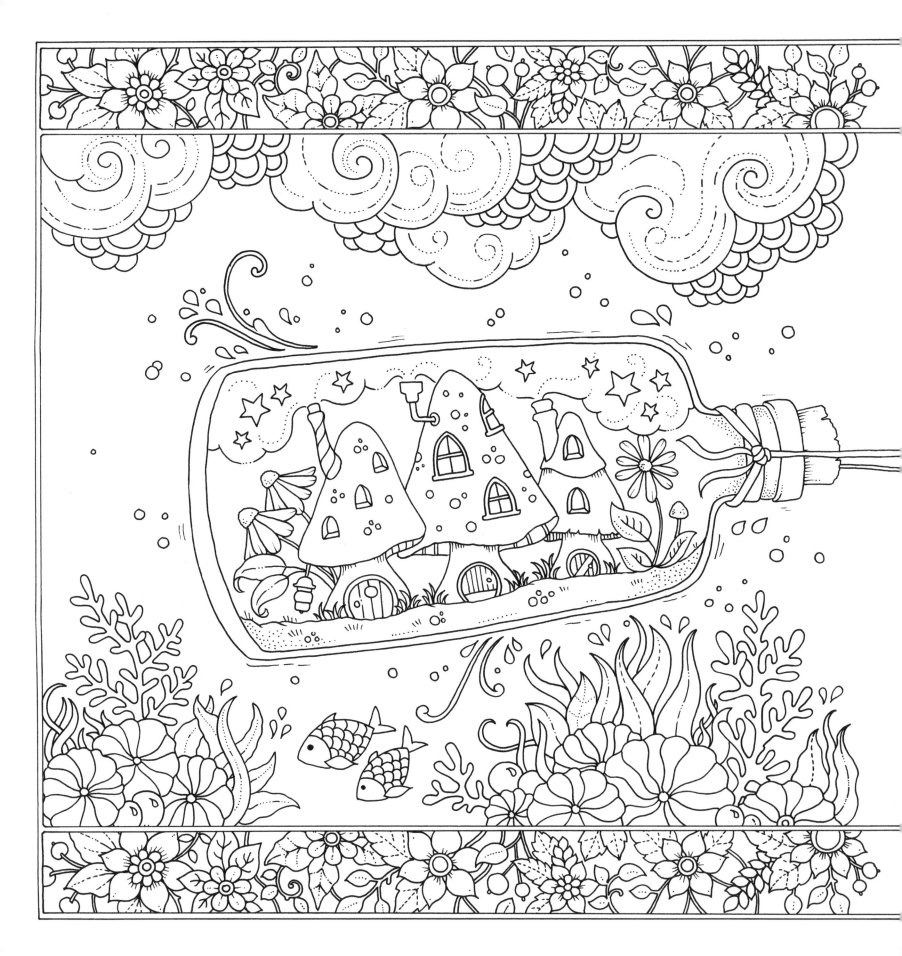

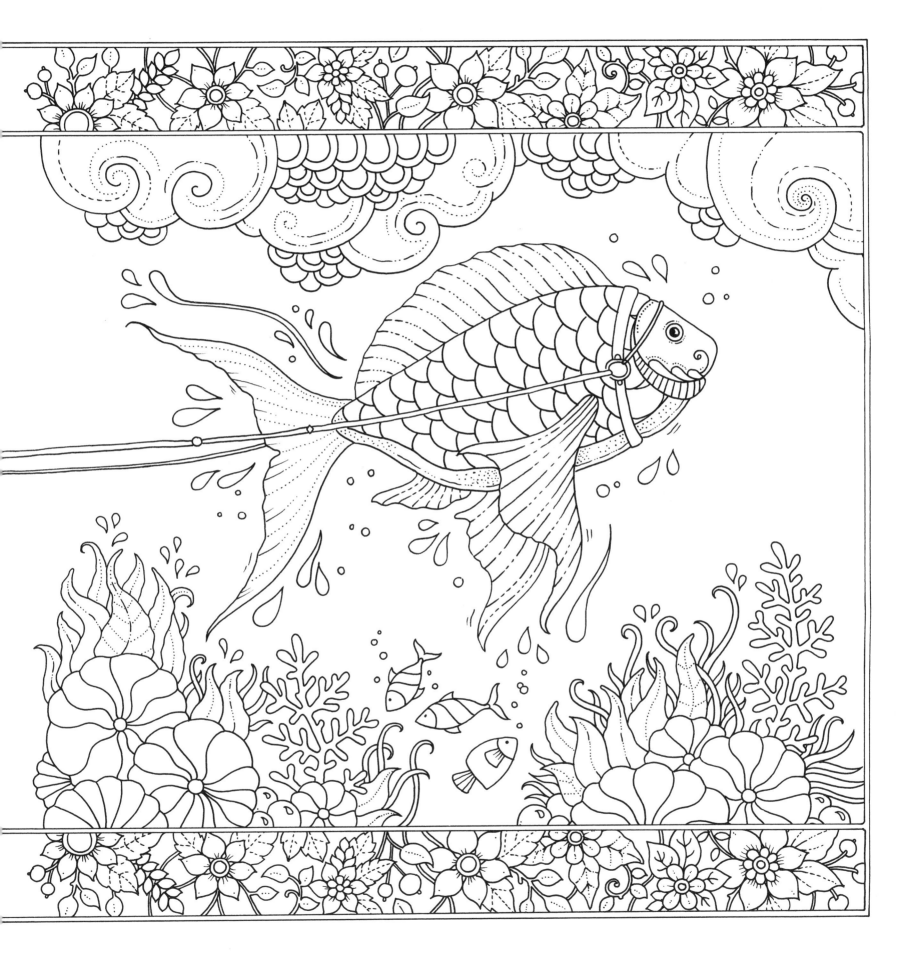

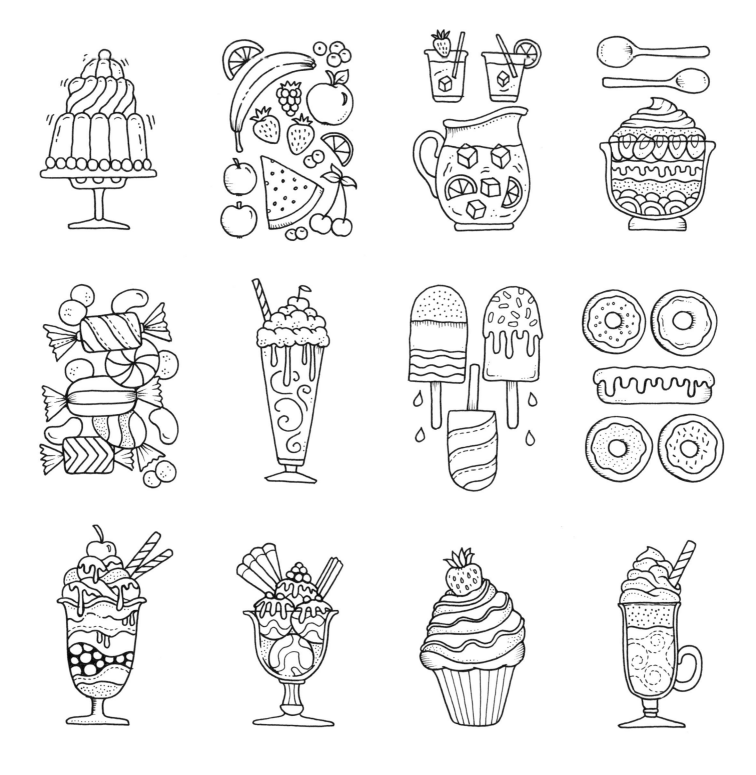

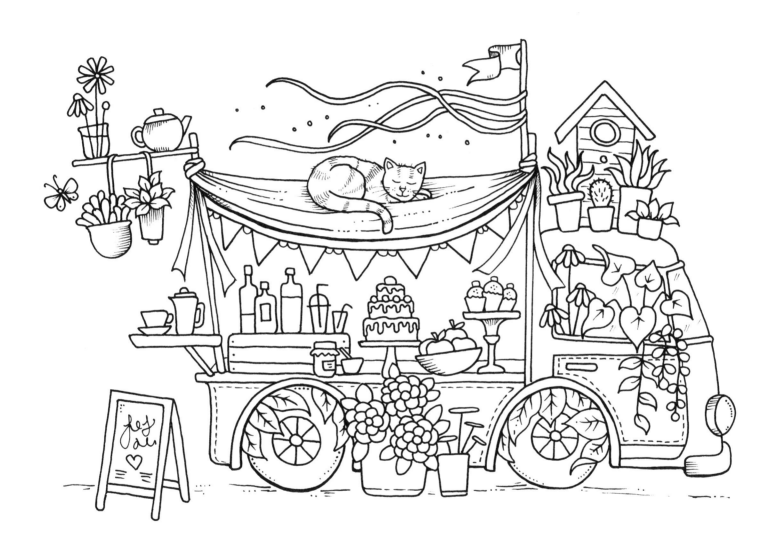

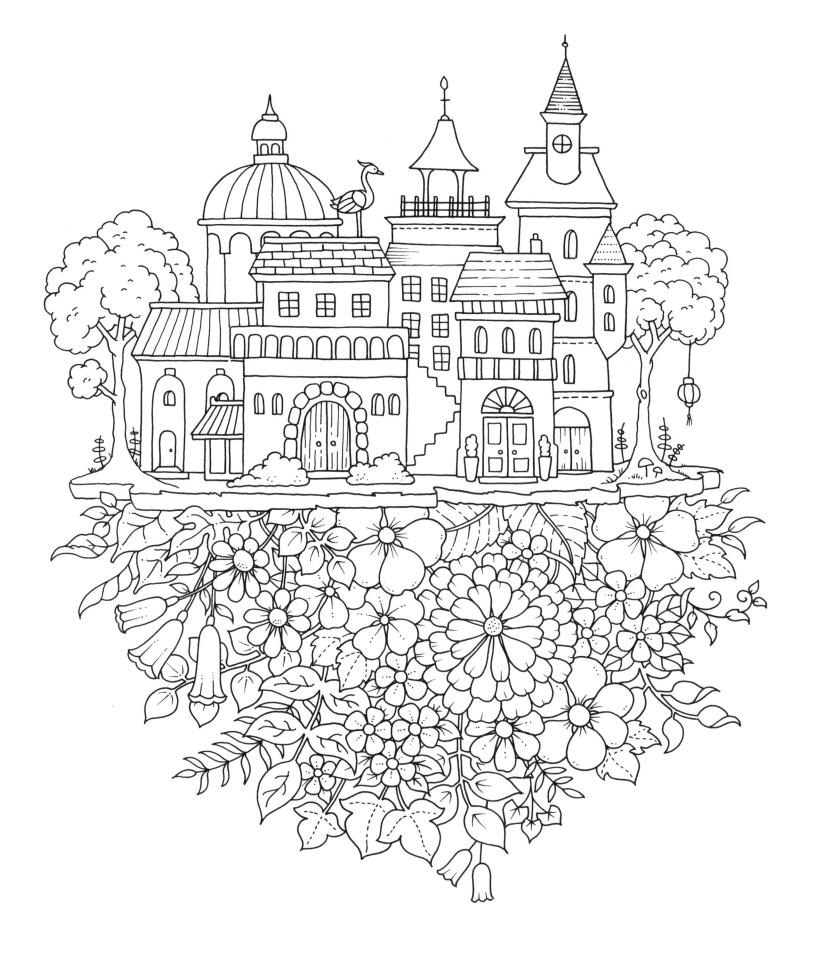

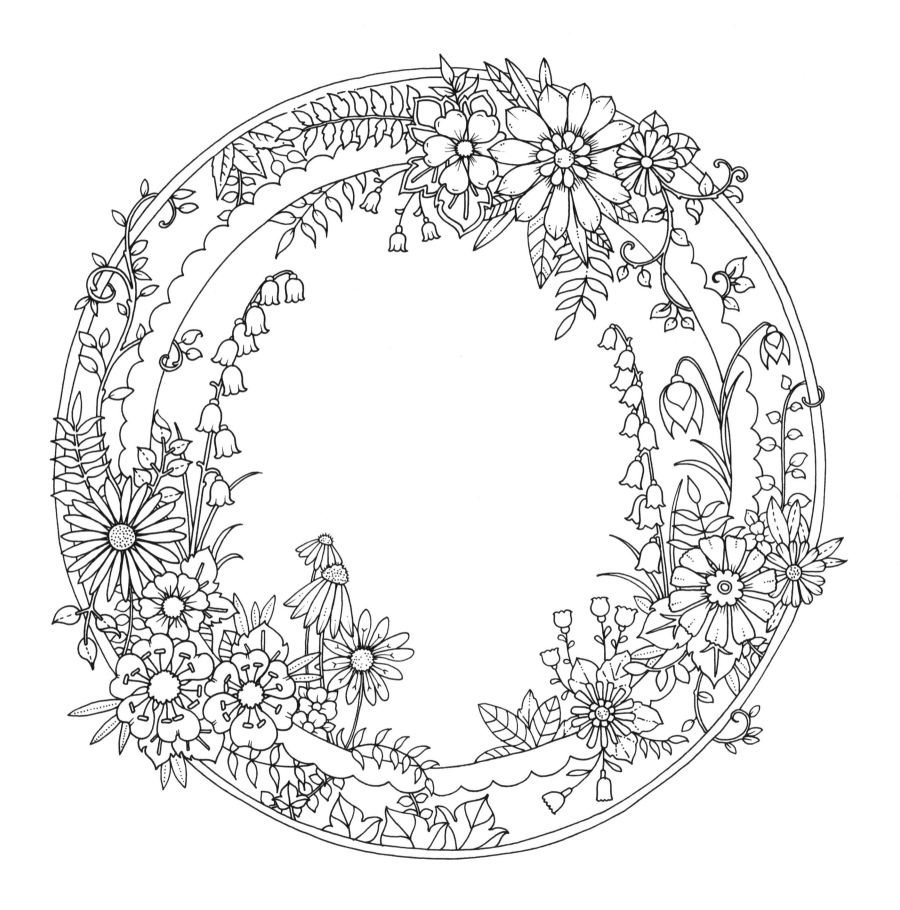

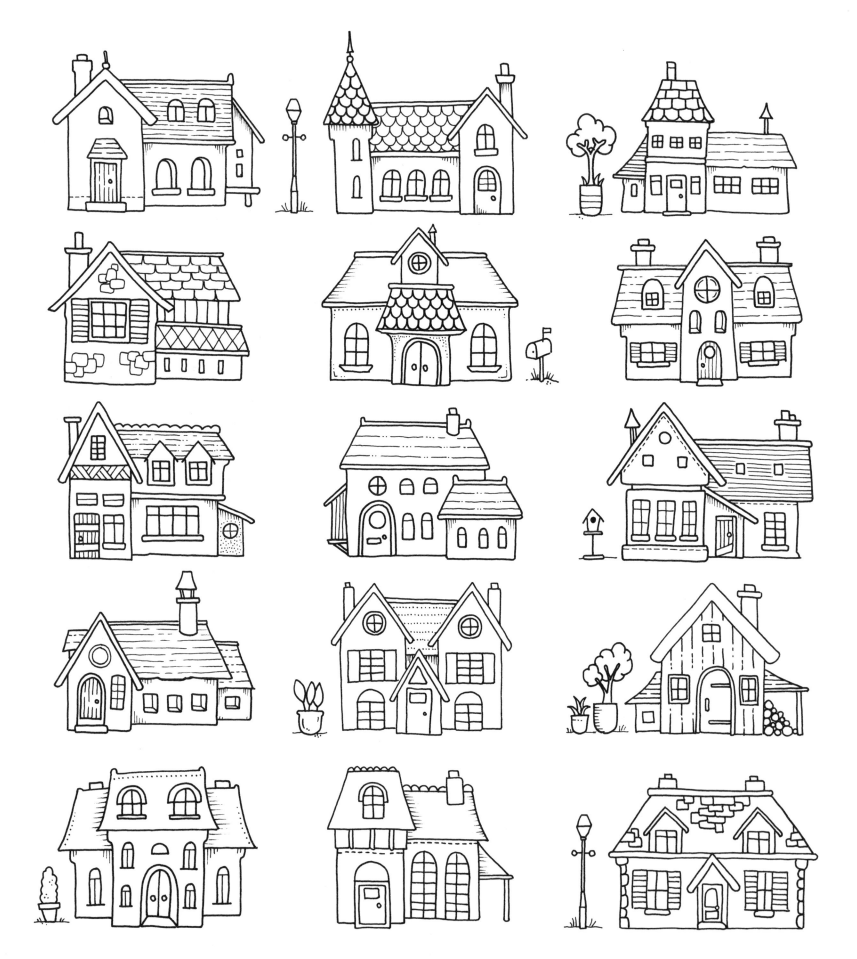

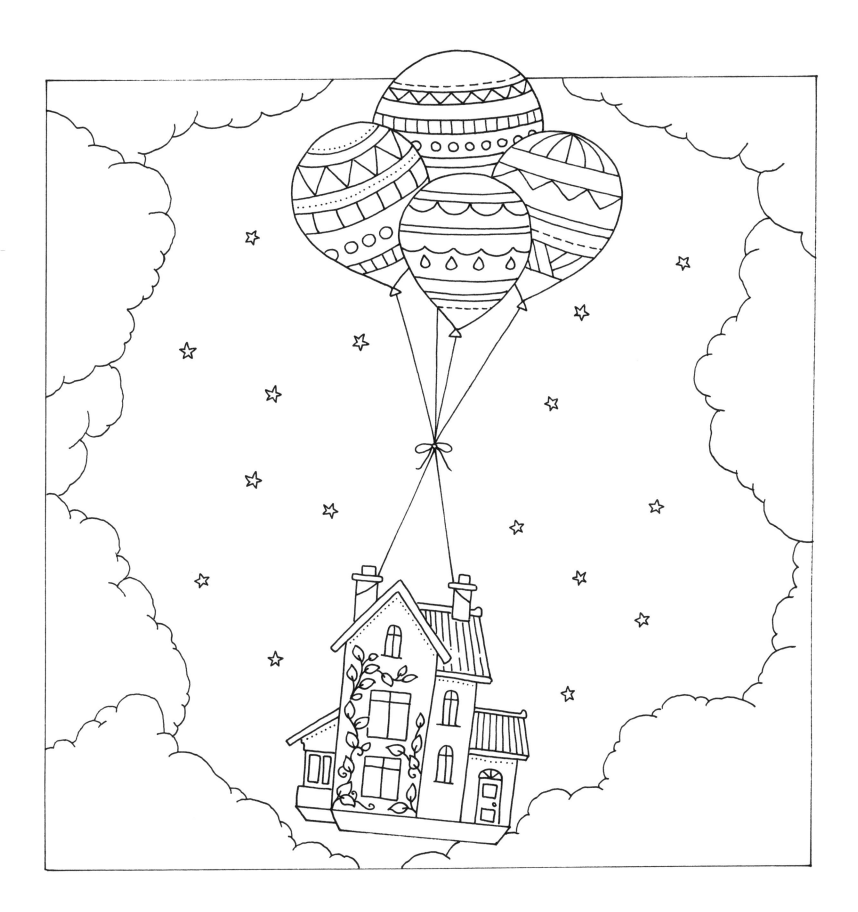

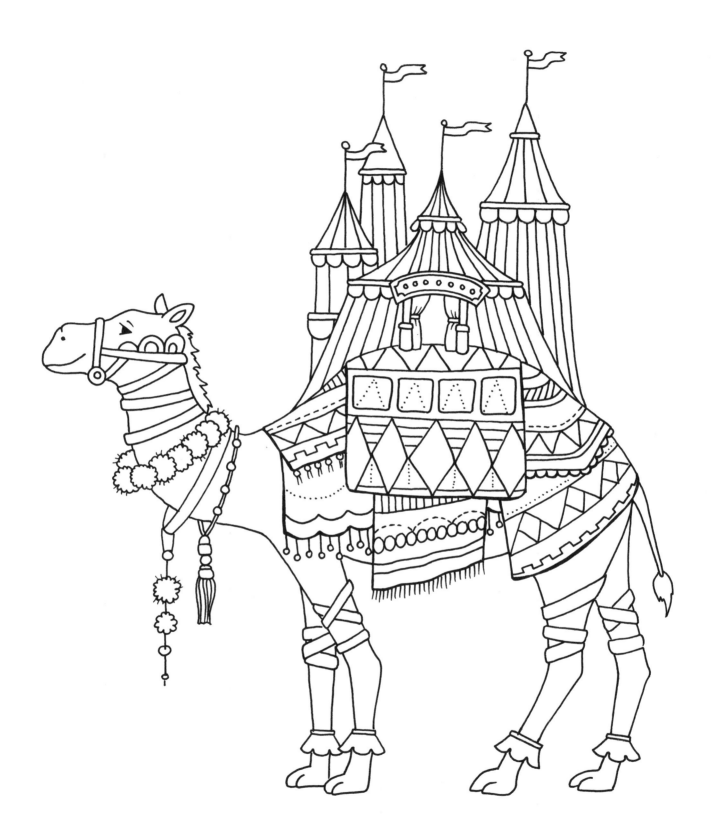

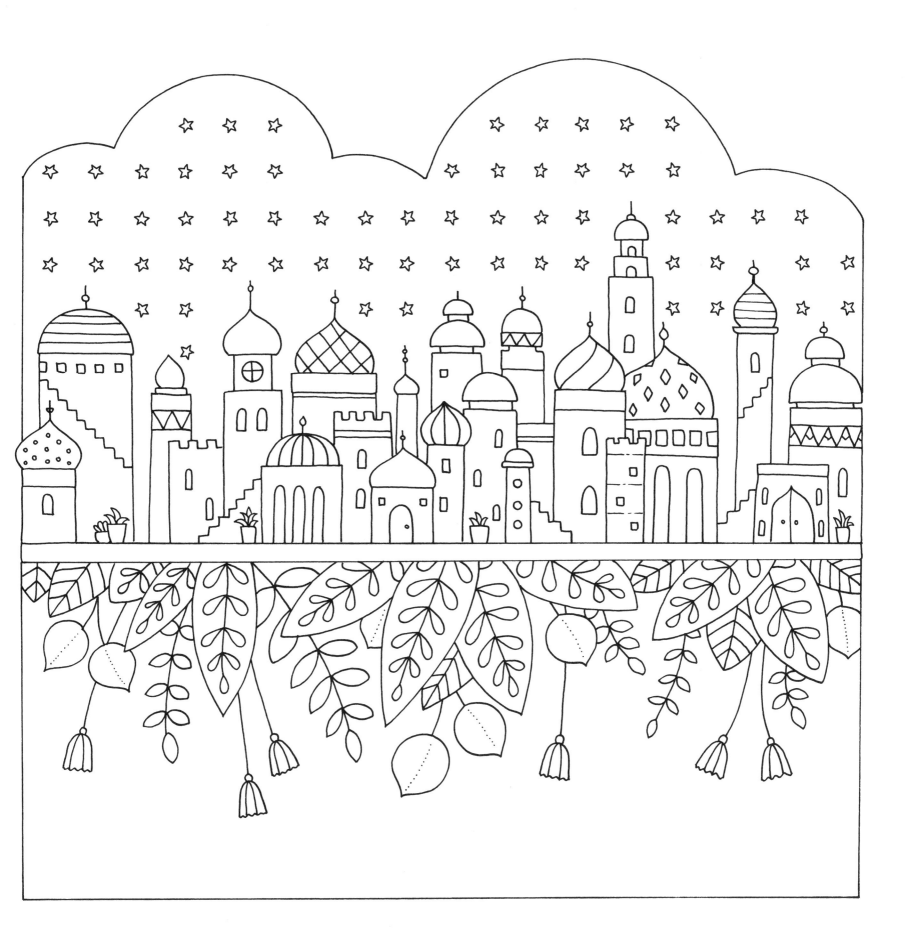

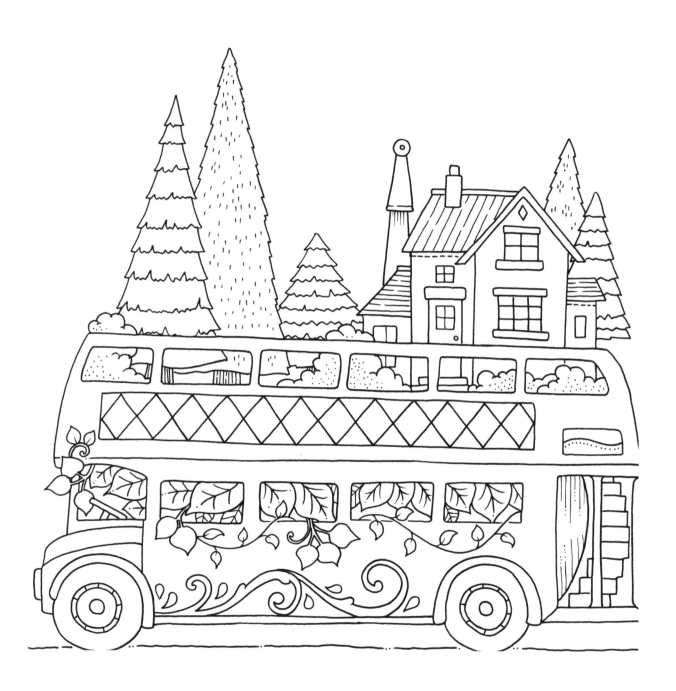

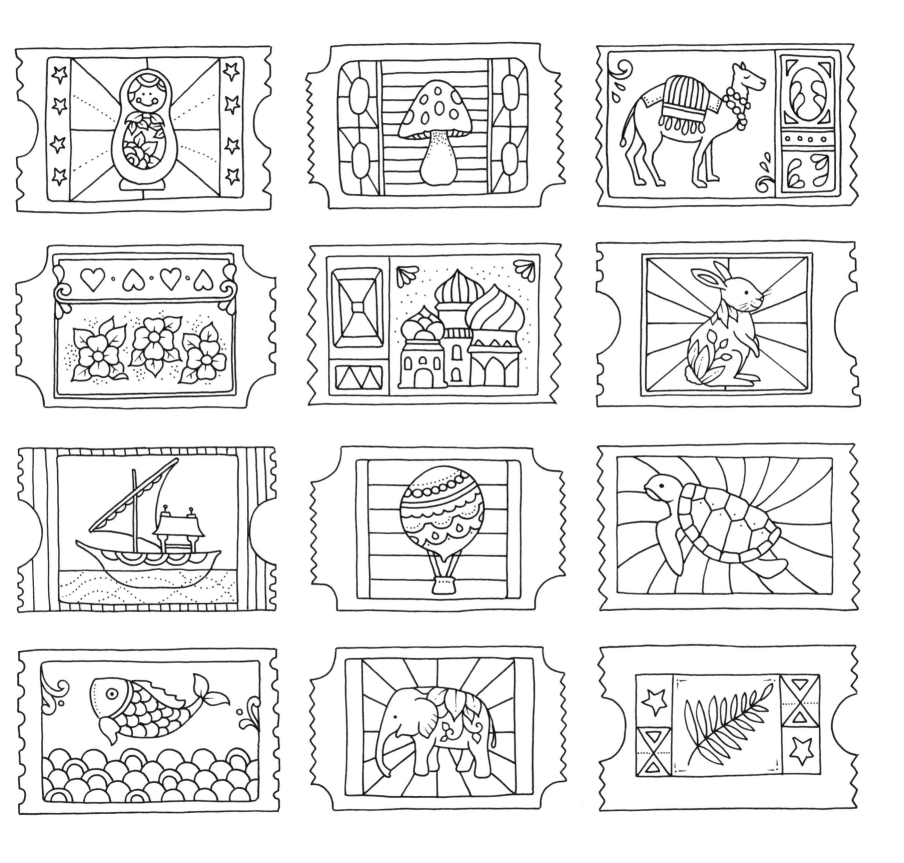

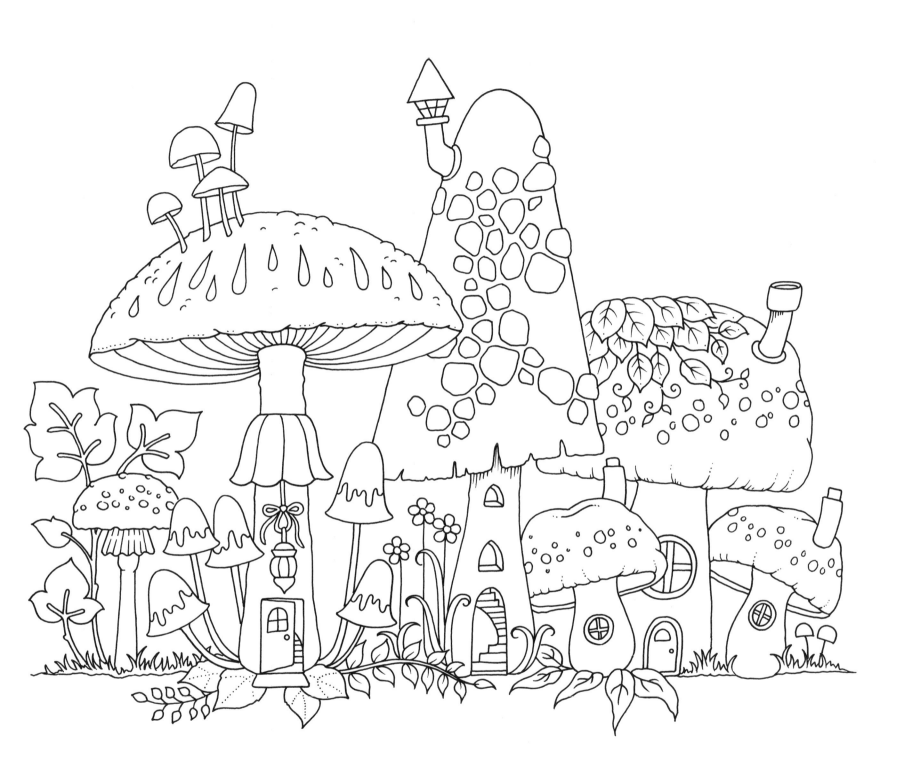

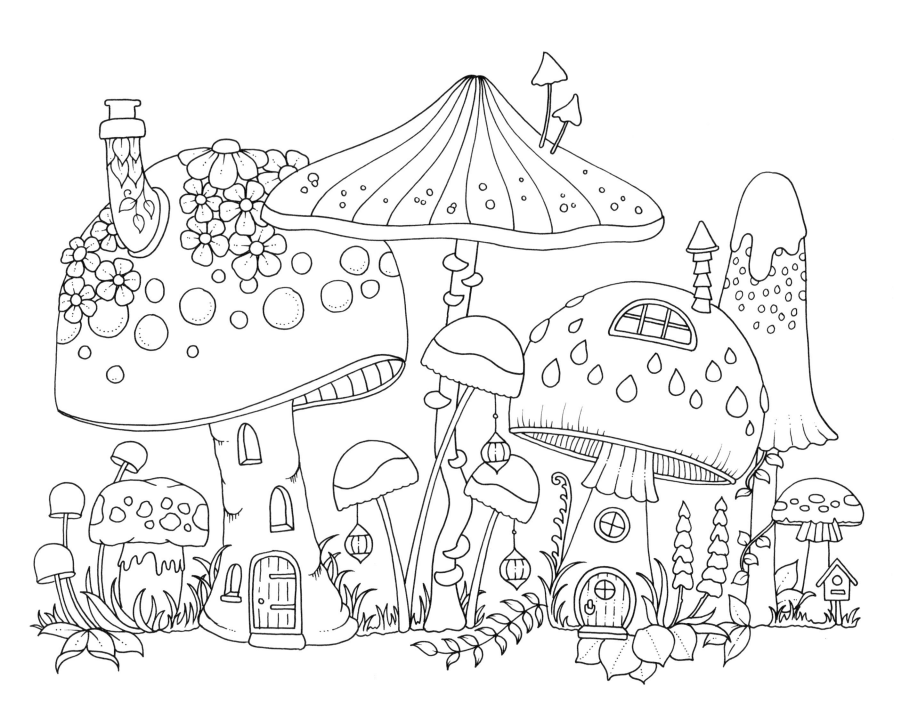

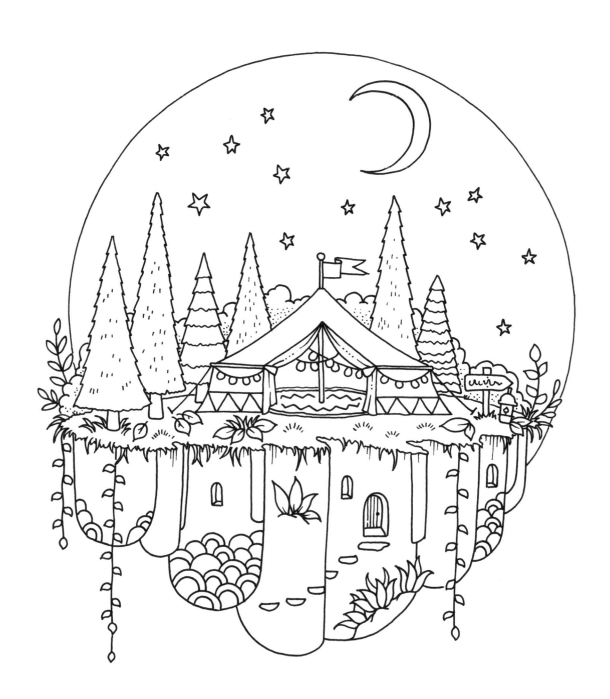

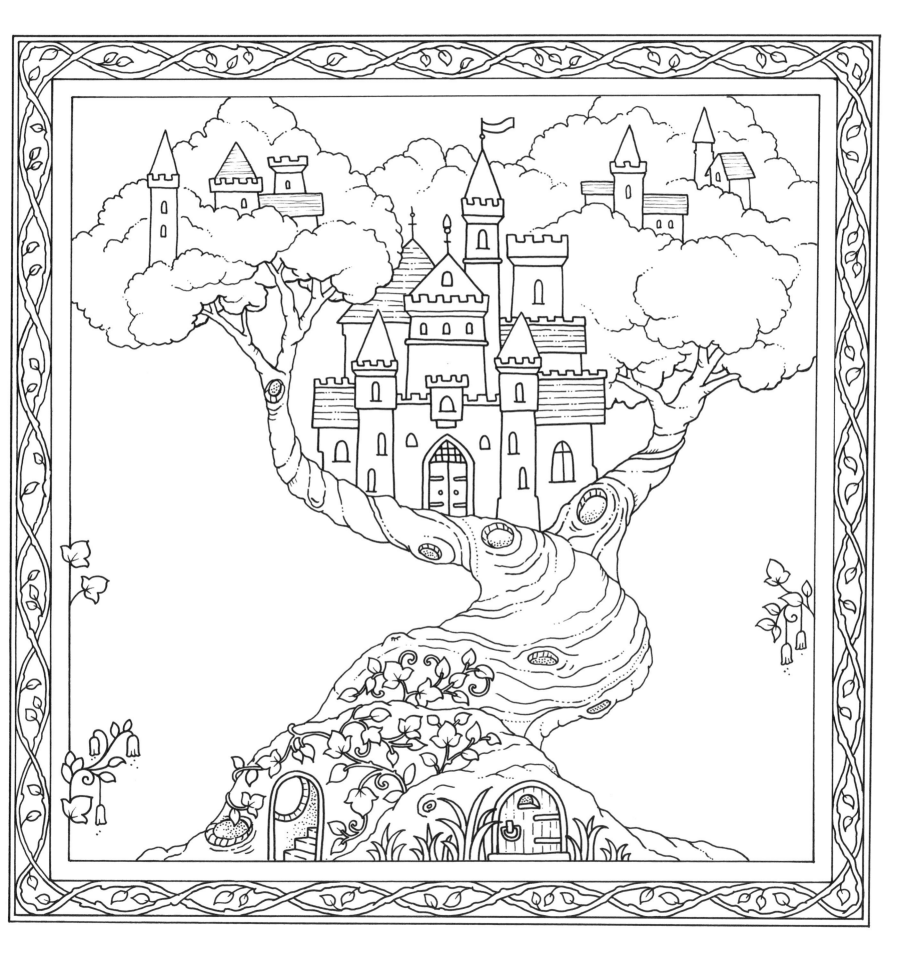

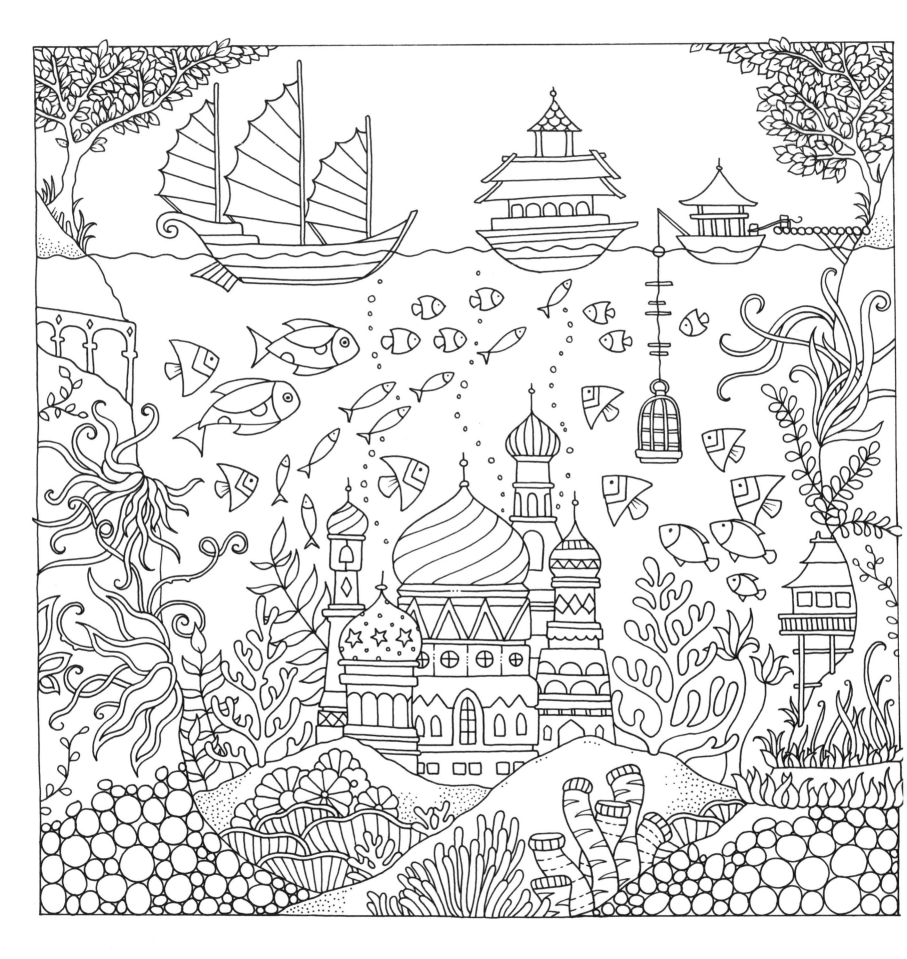

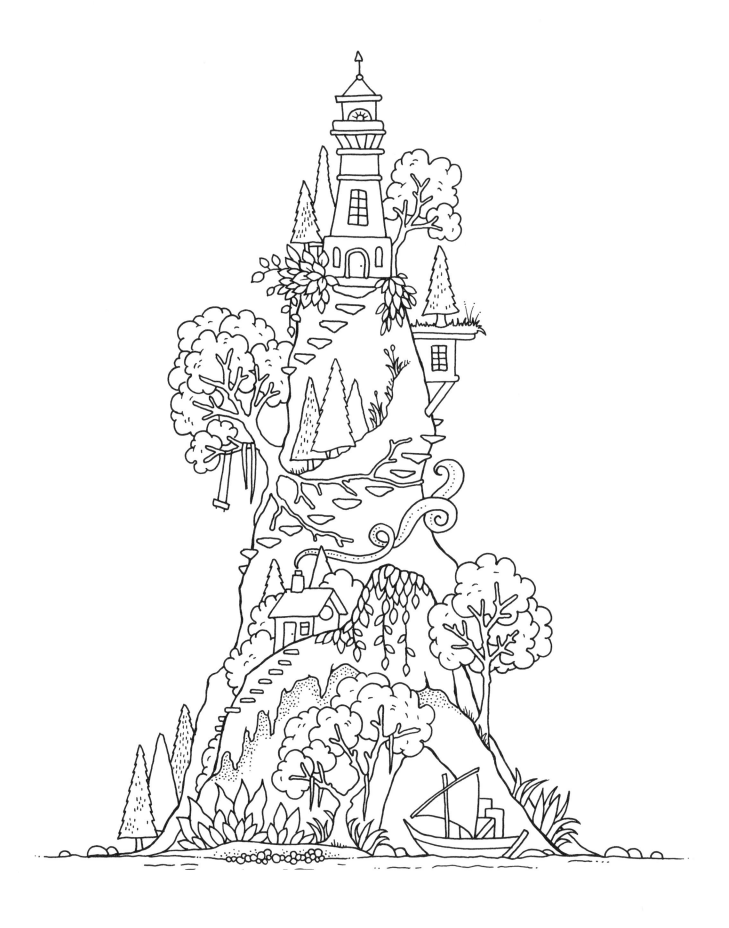

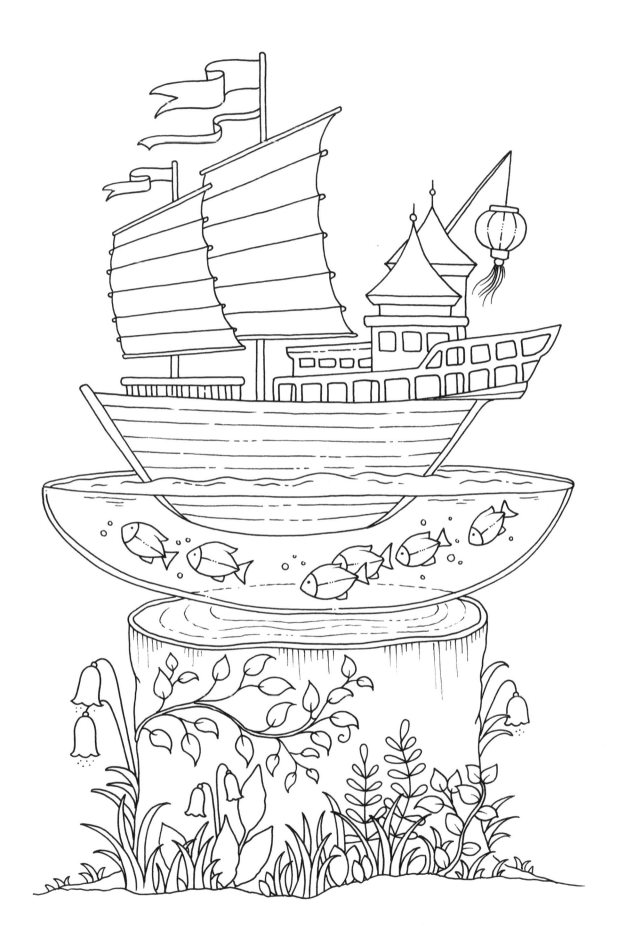

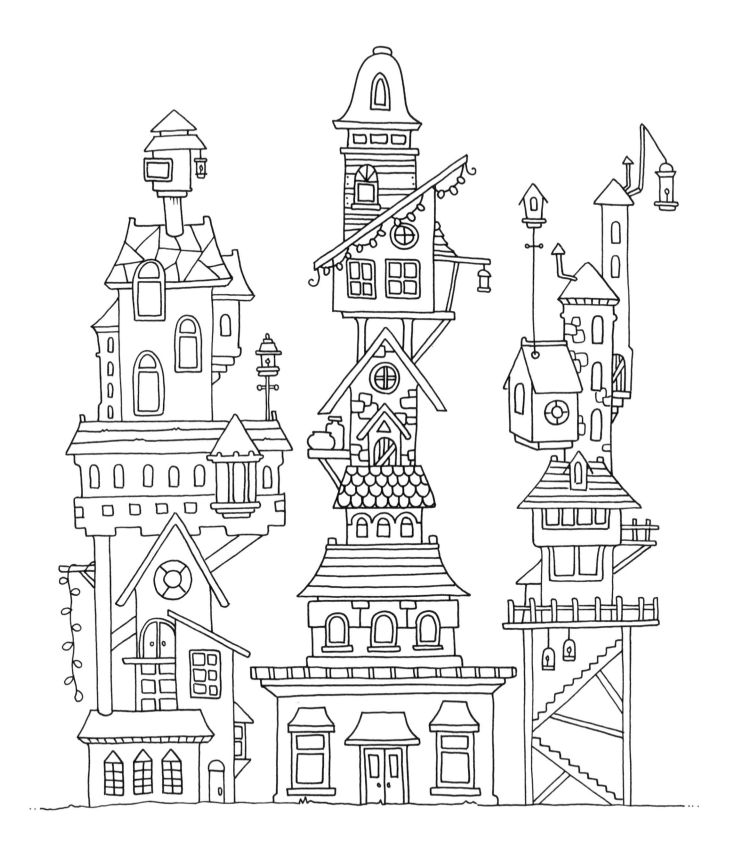

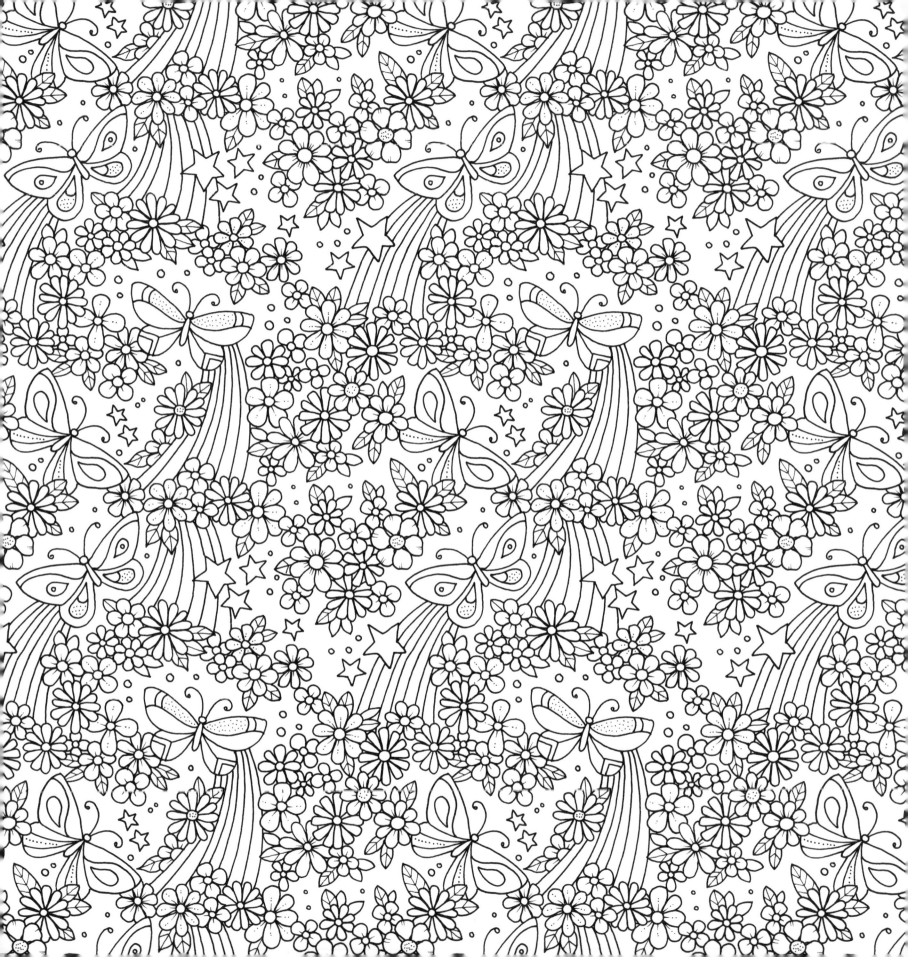

Color Palette Test Page

Color Palette Test Page